From Pop to the Pit

LAPL Photo Collection Celebrates the Los Angeles Music Scene, 1978–1989

Edited by
Wendy Horowitz and Christina Rice

photo
friends

LOS ANGELES PUBLIC LIBRARY

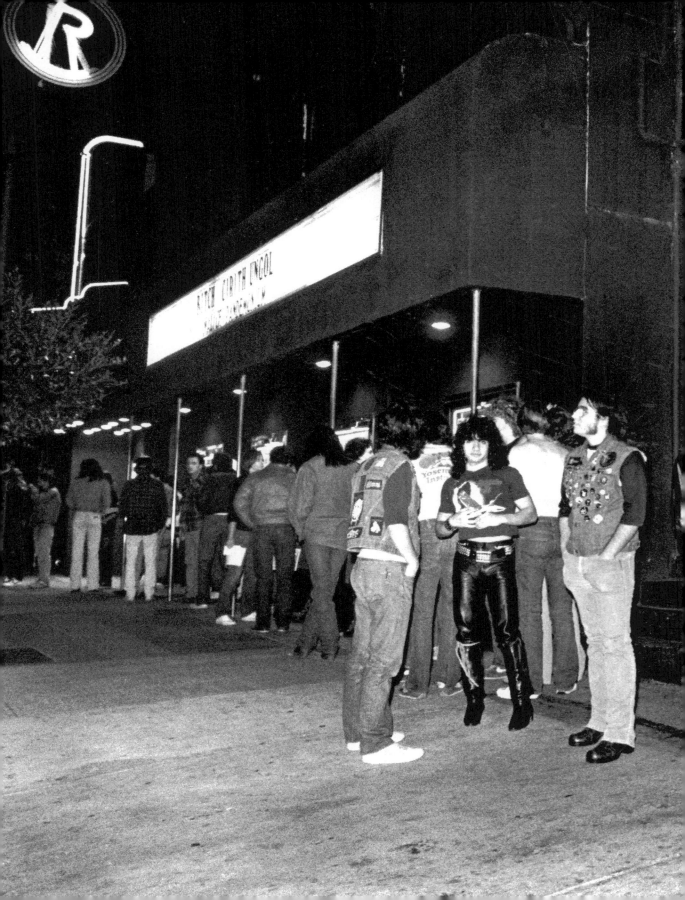

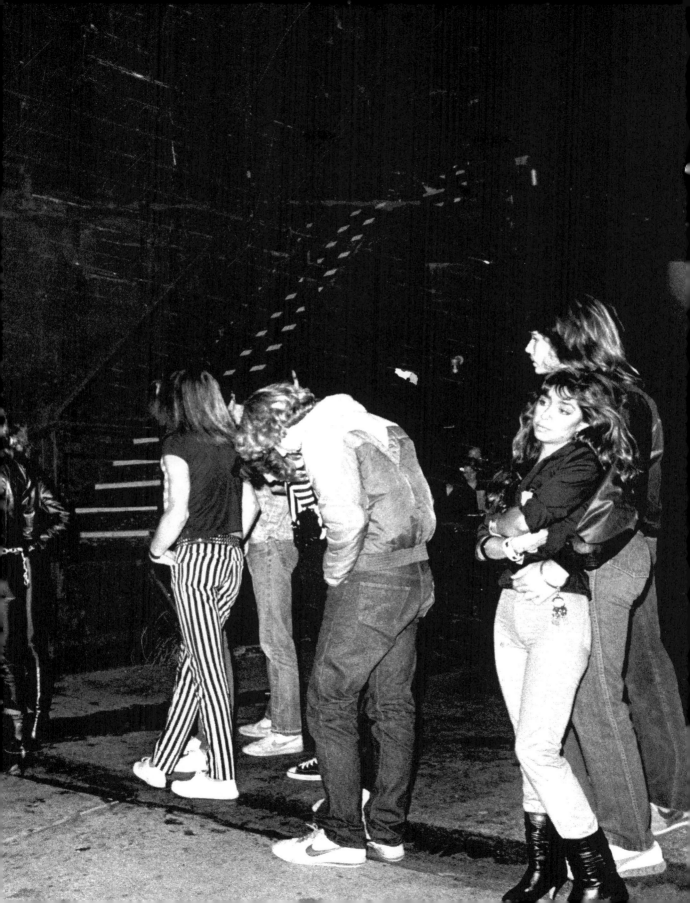

Introduction

Rock genres collided in 1980s Los Angeles, creating a kaleidoscope of sounds unmatched by any other city for its variety. The terrain of Southern California, by its very diverse nature, spawned likewise diverse talent. The beach communities, the Valley, South Central, the Inland Empire, East L.A.—each had its own flavor, infused in the local music. Together these bands created an indigenous imprimatur, a unique combination of audacity, theatricality, bravado, pitch-perfect harmonies, and an uninhibited sense of humor. In addition, with the major record labels headquartered here since the gradual shift in the late-sixties, it became the center of the music industry, and by the end of the 1970s Los Angeles had everything an ambitious rock group could hope for—an abundance of clubs, school dances, and rehearsal spaces for playing; and the ubiquitous A&R executives that regularly made the rounds, seeking new talent to sign.

While snobbish music journalists panned heavy metal with snarky reviews, the bands' devoted fans crammed every venue they played, sending them to the top of the charts and to platinum selling-status. It was a very good decade for the music industry, with more bands being signed in L.A. and more revenue being generated from L.A. bands than in any other place and time since the 1950s.

However, when it came to L.A.'s hugely influential alternative rock scene, surprisingly little coverage of it exists in the *Herald Examiner* photo archive. According to one staffer, the smaller clubs were simply too dark and crowded and altogether inhospitable to photographers. Then finally in 1988, Lucy Snowe, a freelance photographer, and columnist Gregory Sandow, formerly of

the *Village Voice*, ventured out three nights a week seeking the most unusual, entertaining, and buzz-worthy bands in L.A. to review for the weekly alternative music column "Nite Flash." They withstood the slamming, sweat, and blaring amps until the paper folded in 1989.

Meanwhile, the free press did chronicle the local music scene, with papers such as the *L.A. Weekly*, *L.A. Reader*, *BAM*, *Rock City News* and *Music Connection* providing weekly recaps on the nightly gigs around town. Photographer Gary Leonard, a regular contributor to the *Weekly* and the *Reader*, helped us fill in the gaps by generously donating images from his club days for the exhibit, including a never-before published portrait of Mötley Crüe from 1983.

While we couldn't include all of the legendary and influential bands of the period, when we looked at what we found, we were delighted to see that it's the variety that comes across—the unmistakable stamp of Los Angeles that we present to you here. Welcome to From Pop to The Pit, and everything in between.

Wendy Horowitz
Photo Librarian
Los Angeles Public Library

Pages 2-3: The Roxy Theater.
1983, Paul Chinn (Order #45072)

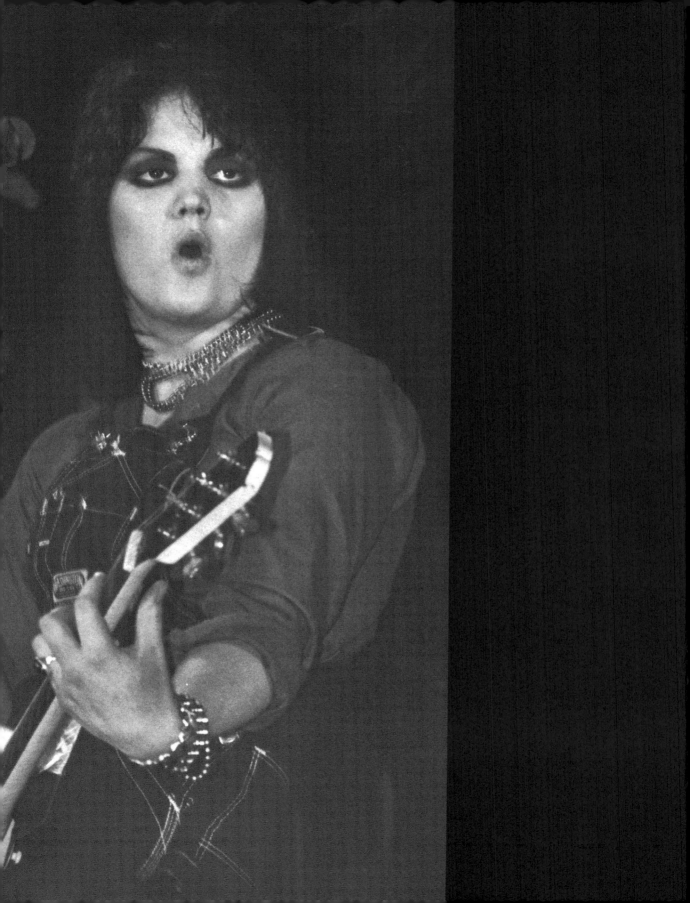

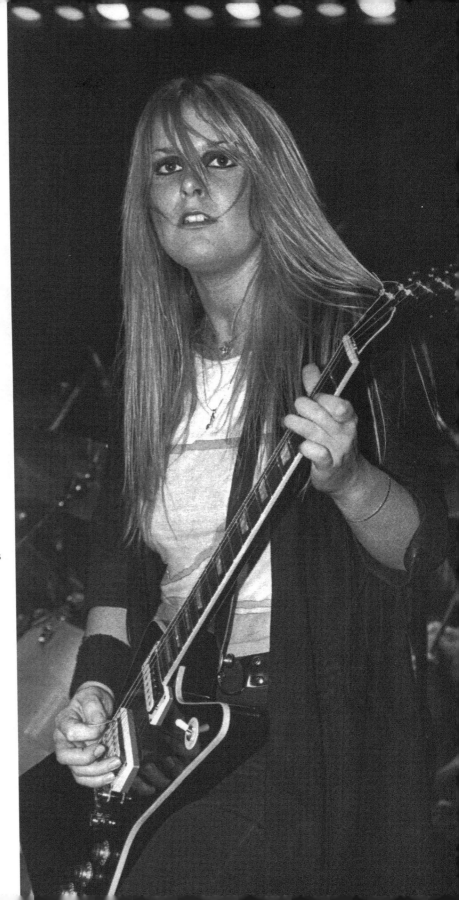

The Runaways
Joan Jett, left
and Lita Ford,
right. While they
never achieved
major commercial
success during
their tenure
together, the
Runaways played
to sold out
venues all over
Los Angeles in
the 1970s and
headlined shows
with Van Halen,
Cheap Trick and
Tom Petty and
the Heartbreakers
as opening acts.
1978, Dean
Musgrove
(Order #121786 and
#121787 opposite)

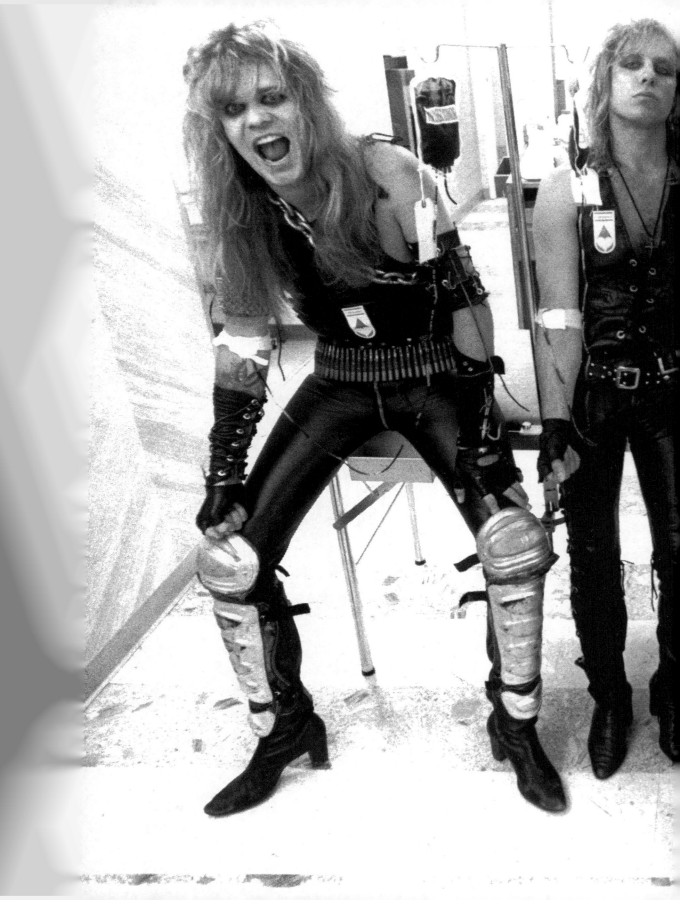

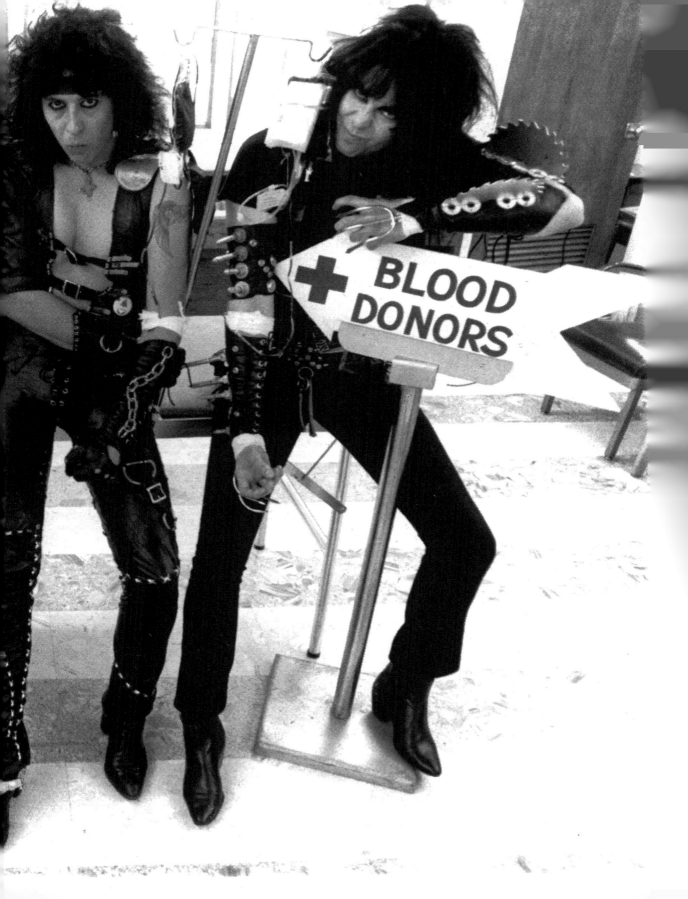

Social Distortion. Lead singer Mike Ness, left, and Dennis Danell, guitarist. Orange County natives Social Distortion gained a huge following with hardcore punk fans, and have sold over three million albums worldwide. They are still performing and recording material today.
1983, Chris Gulker (Order #121788)

Overleaf: **W.A.S.P.** Capitalizing on their reputation for outrageous onstage antics, Chris Holmes, Tony Richards, Blackie Lawless and Randy Piper enjoy a unique photo opportunity while promoting a good cause at an American Red Cross Blood Drive, which they co-sponsored.
1983, unknown (Order #121772)

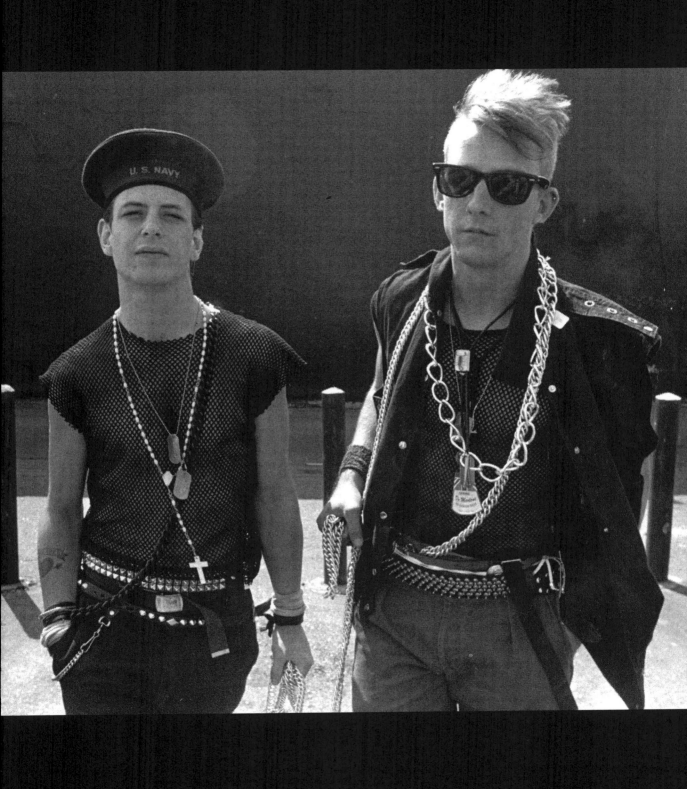

Burning Tree. Marc Ford, guitarist and founder of hard rock/blues hybrid
Burning Tree.
1989, Lucy Snowe (Order #124271)

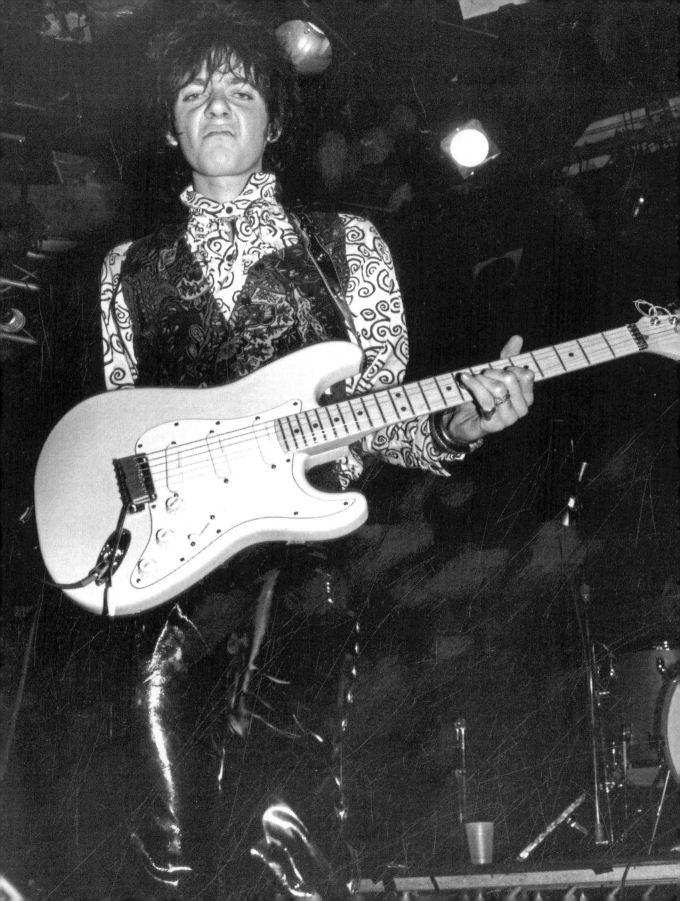

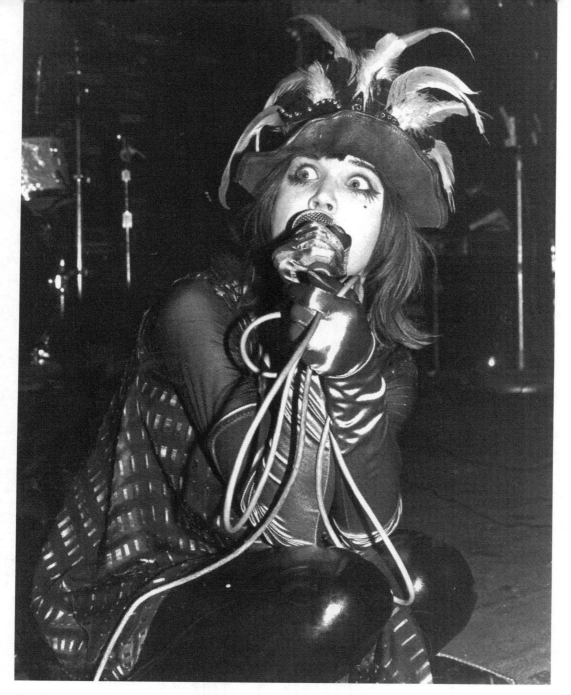

The Nymphs. Inger Lorre, lead singer, performing at The Music Machine. Despite a cult following and regular appearances in Hollywood clubs, the alternative rock band was plagued with record label woes and controversy, including an incident involving a drunken Lorre reportedly urinating on the desk of a Geffen A&R executive. 1989, Lucy Snowe (Order #121767)

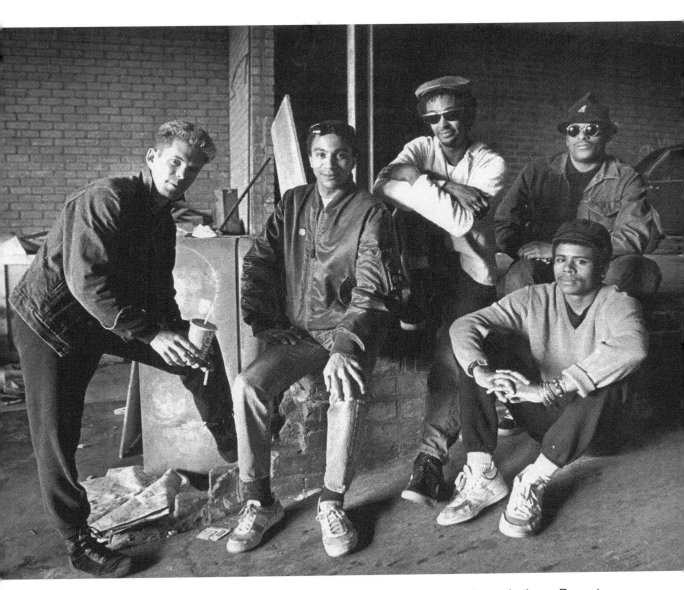

The Untouchables. Glenn Symmonds, Clyde Grimes, Caine Carruthers, Anthony Brewster, Jerry Miller. Formed in 1981 during the mod revival in L.A., The Untouchables were the city's first ska-influenced band. Wildly popular, they packed in the crowds at clubs on the Sunset Strip and appeared as a scooter gang in the cult hit film *Repo Man.*
1986, Leo Jarzomb (Order #121768)

The Unforgiven. John Hickman, John Henry Jones, Mike Jones,
Alan Waddington, Mike Finn and Todd Ross.
1985, Paul Chinn (Order #124261)

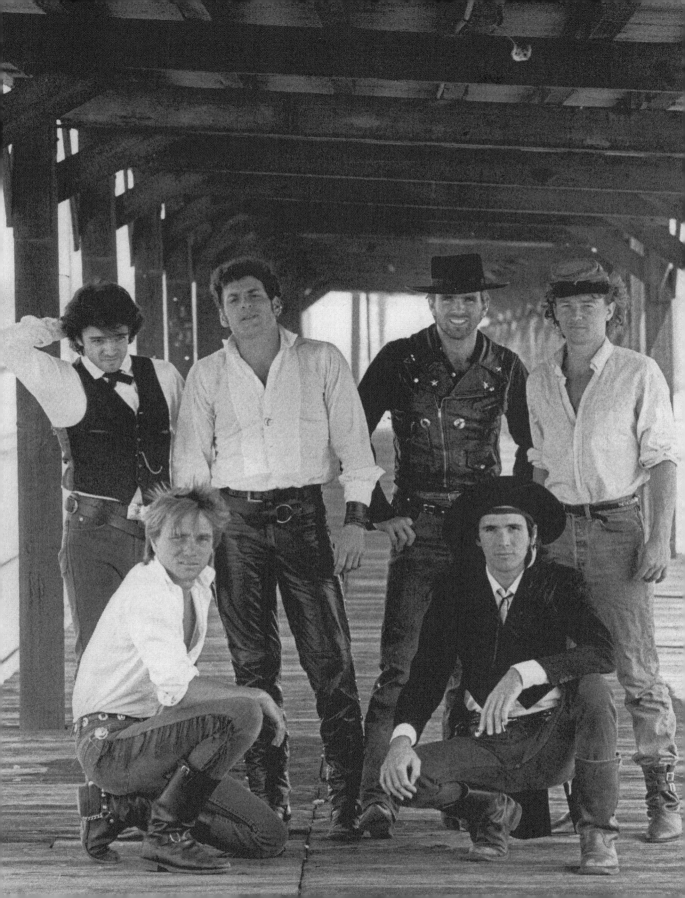

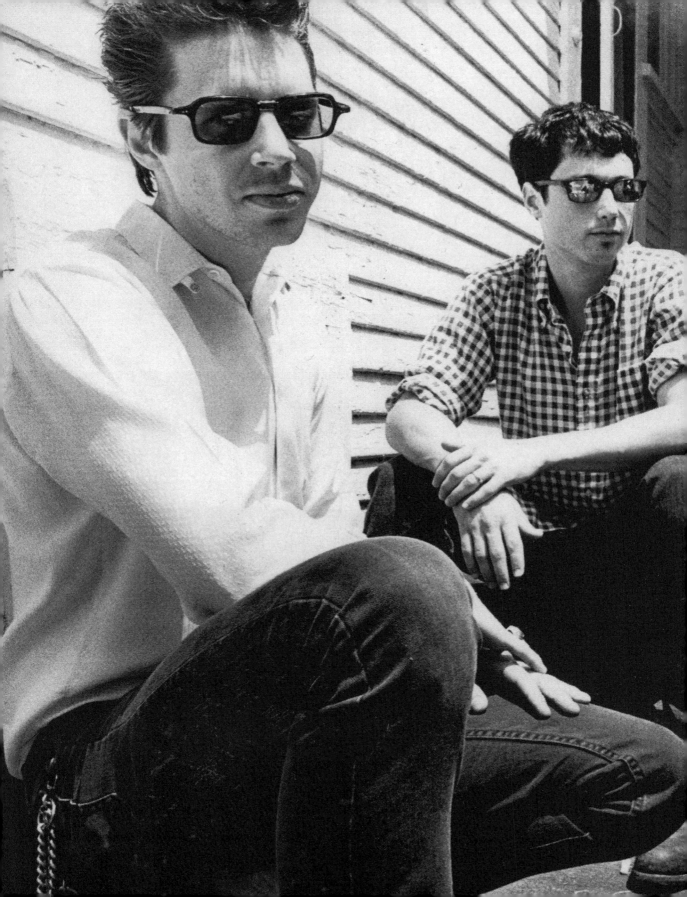

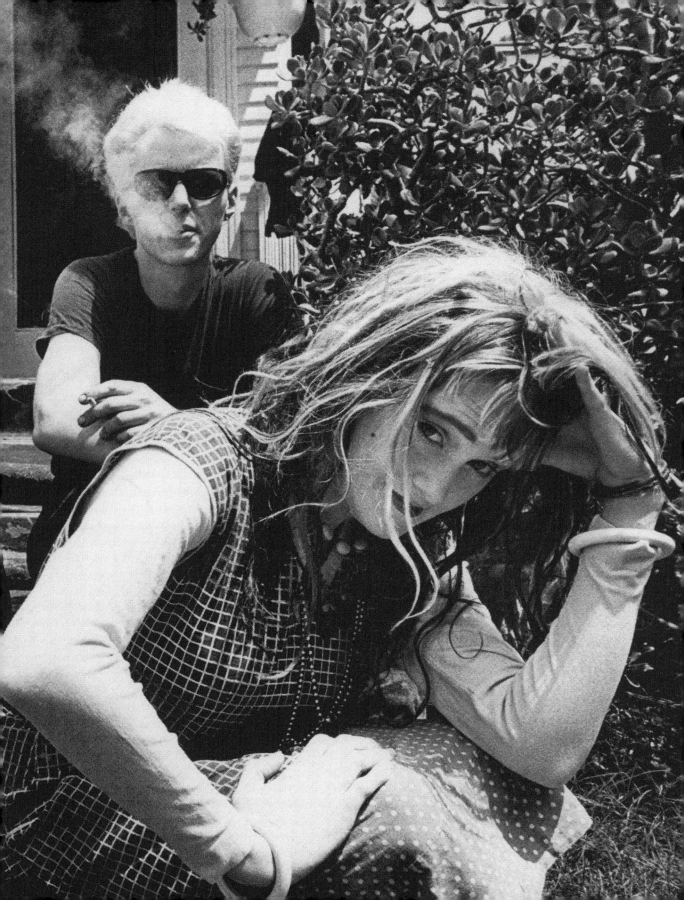

X. Exene Cervenka, lead singer of X.
1982, Dean Musgrove (Order #124285)

Overleaf: **X.** From left, Exene Cervenka, DJ Bonebrake, Billy Zoom and John Doe. One of the first bands to emerge from the Hollywood punk scene in the late 1970s, X were critically acclaimed for their hybrid of punk, folk, rockabilly and blues. Their albums appear on *Rolling Stone* magazine's list of the 500 Greatest Albums of All Time, and the City of Los Angeles awarded them with an Official Certificate of Recognition for their contributions to the City's musical and cultural heritage.
1983, Anne Knudsen (Order #122979)

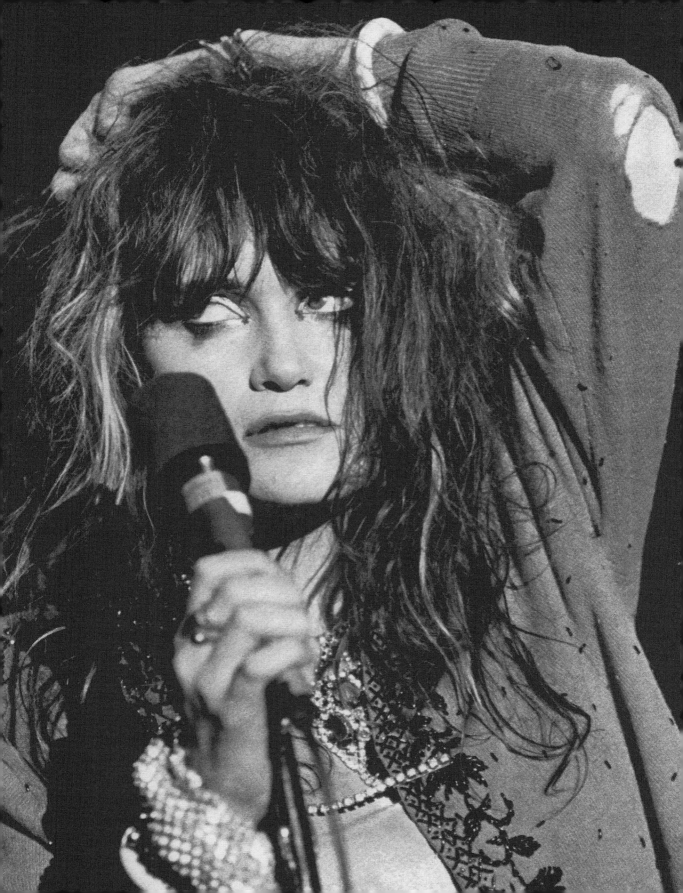

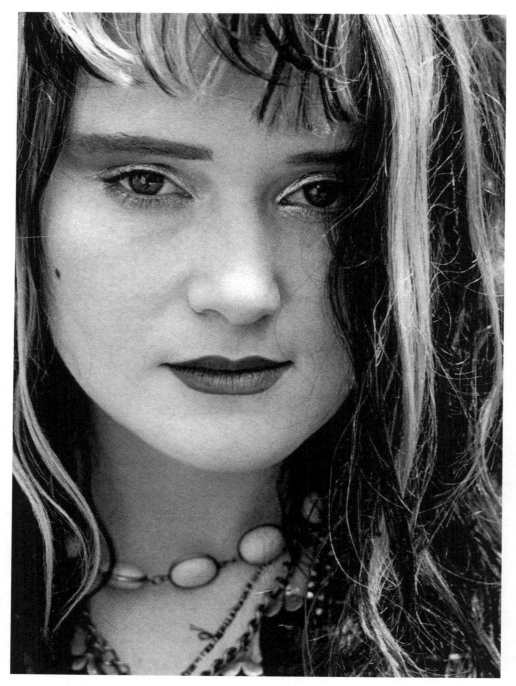

X. Exene Cervenka, lead singer of X.
1981, Dean Musgrove (Order #124286, #124287 opposite)

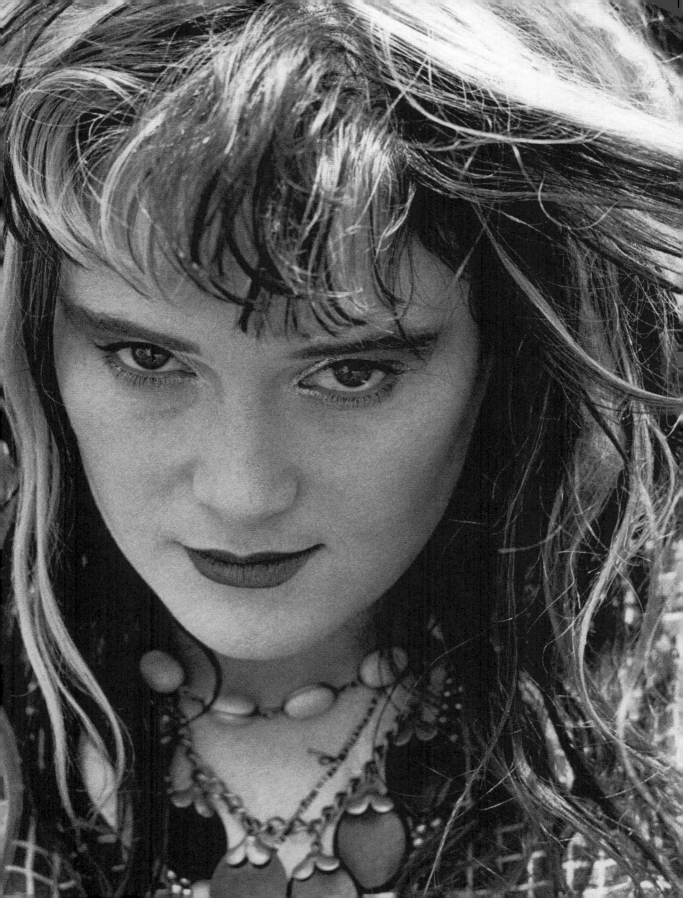

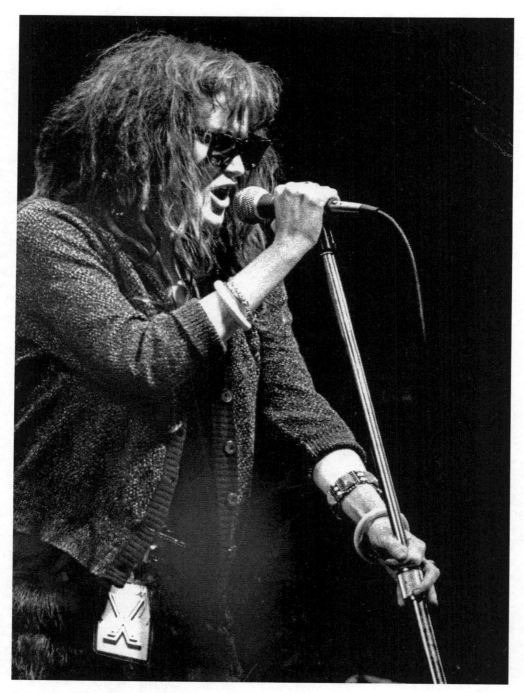

X. Exene Cervenka, lead singer of X.
1983, Anne Knudsen (Order #121765, #124284 opposite)

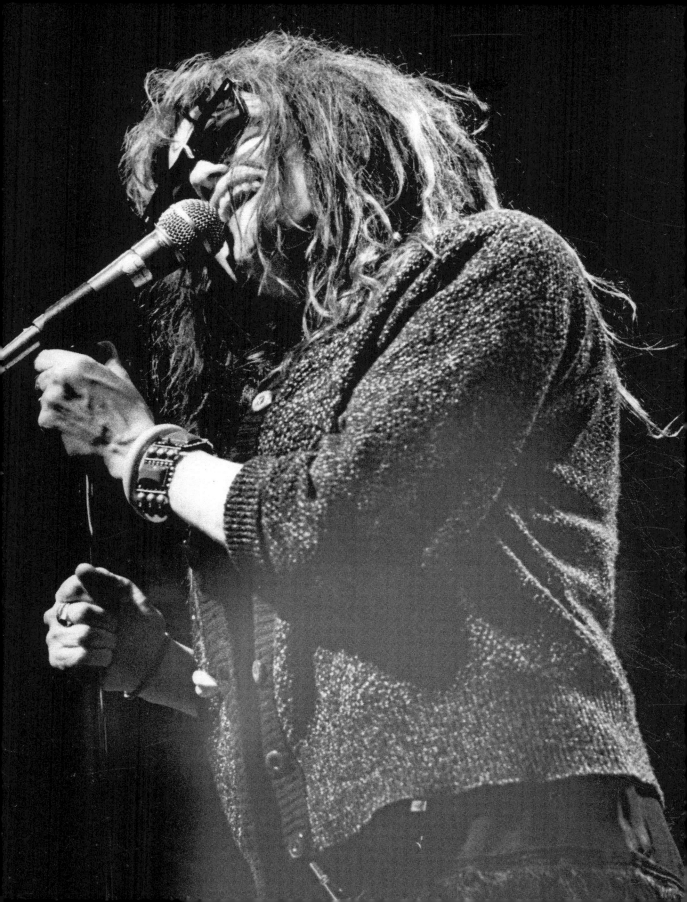

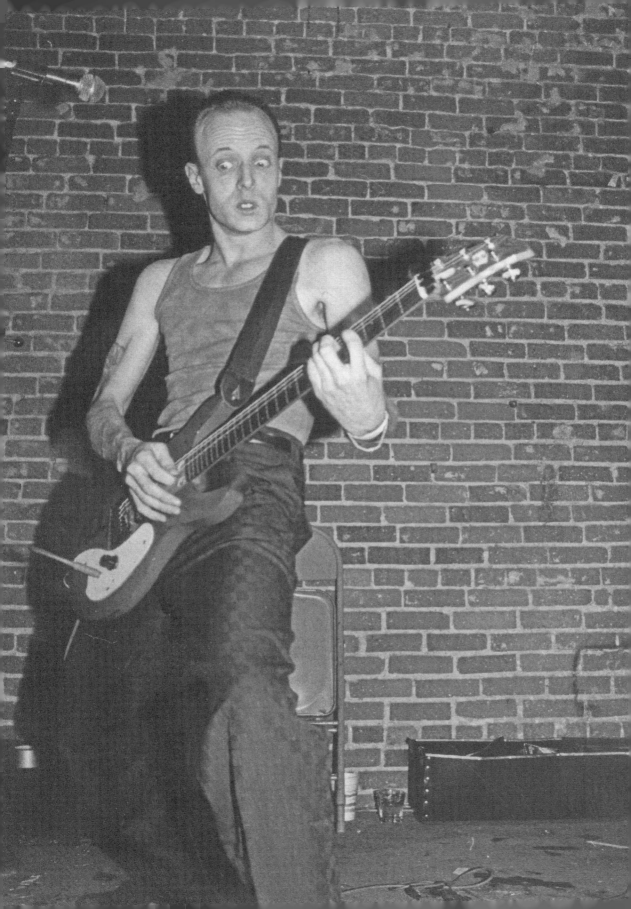

Minutemen. Mike Watt, D. Boone, George Hurley. Founded in 1980 in San Pedro, their rapid-fire "jamming econo" style was a hit with hardcore punk fans and their nationwide success lasted until Boon's death in 1985. Mike Watt and George Hurley have since continued performing on solo projects and in collaboration with members of Jane's Addiction and Sonic Youth.
1983, James Ruebsamen (Order #121792)

Opposite: **All.** Guitarist Stephen Egerton, formerly of the Descendants, performs with his new band All at Club Lingerie. 1989, Lucy Snowe (Order #56455)

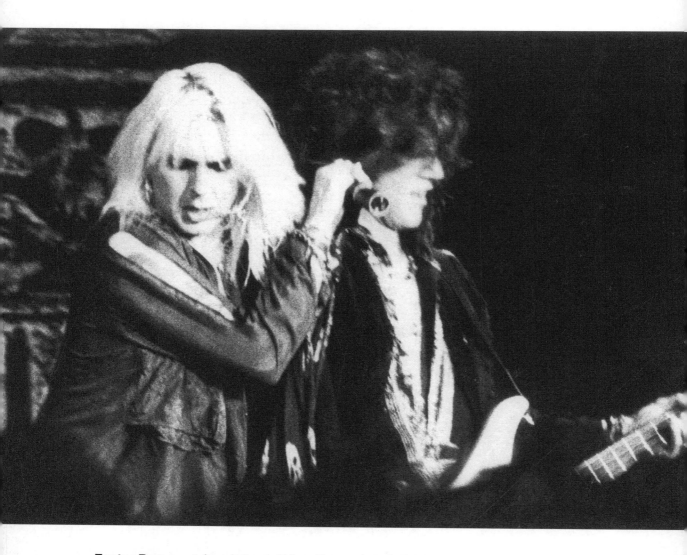

Faster Pussycat. Lead singer Taime Downe headed this local glam metal band who achieved some widespead success with their album *Wake Me When It's Over.*
1989, Lucy Snowe (Order #124270)

Opposite: **Jetboy.** Lead singer Mickey Finn. Originally from San Francisco, Jetboy relocated to L.A. in 1986 and one year later, lost their bassist Todd Crewe to a drug overdose, prompting friends Guns N' Roses to regularly dedicate "Knockin On Heaven's Door" to him.
1989, Lucy Snowe (Order #121773)

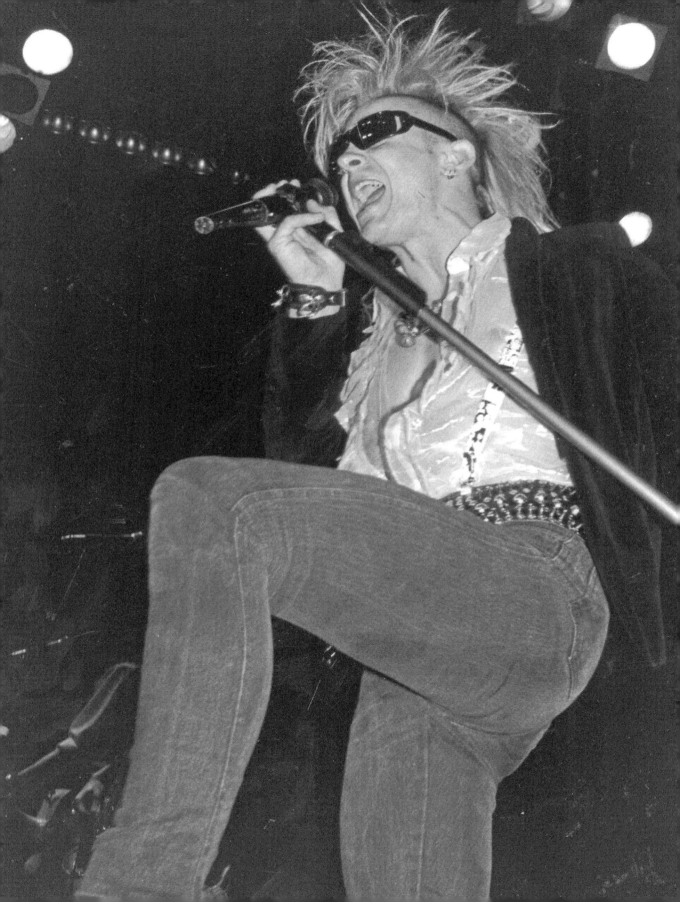

The Go-Go's. Live at the Greek Theater, August, 1984. (Order #124295)

Overleaf: **The Go-Go's.** Gina Schock, Belinda Carlisle, Jane Wiedlin, Kathy Valentine and Charlotte Caffey. Originally a punk band that emerged from Hollywood's infamous Masque club, the Go-Go's' bright, catchy pop tunes were a hit with both new wave and mainstream audiences. They are the first all-female rock band to write their own songs and play their own instruments in the studio, and their first release *Beauty and the Beat* was one of the most successful debut albums of all time. 1981, Anne Knudsen (Order #121784)

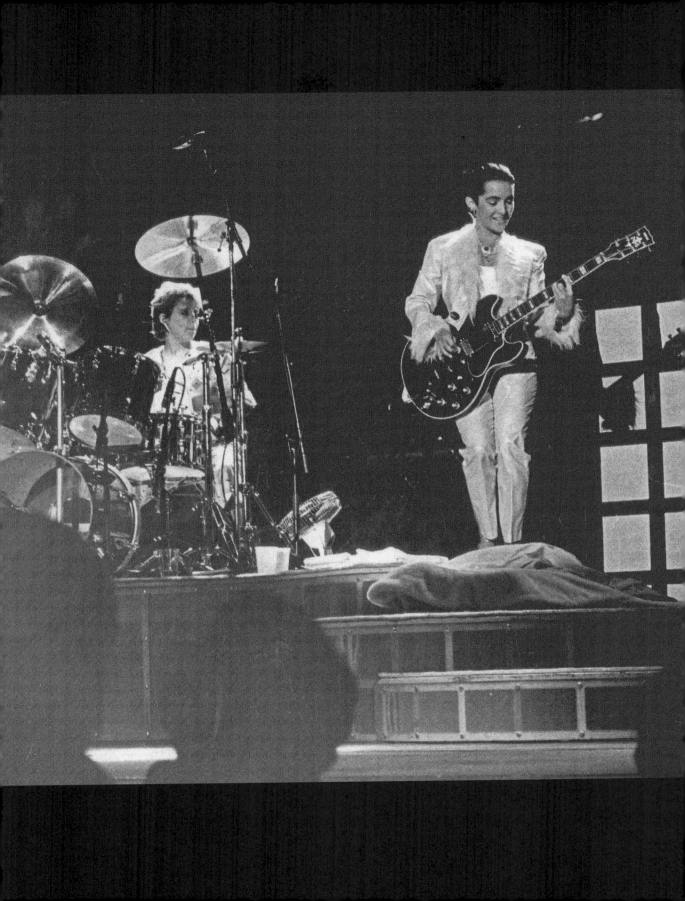

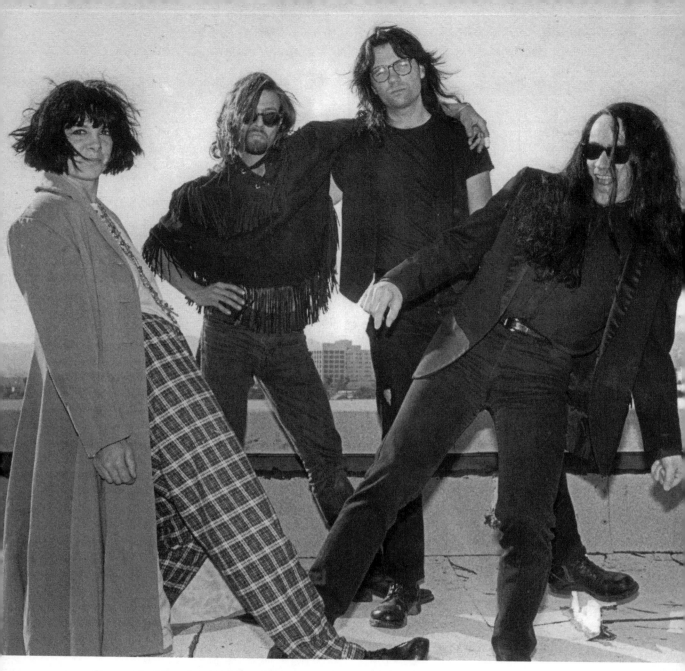

Concrete Blonde. Johnette Napolitano, Harry Rushakoff, Alain Bloch, Jim Mankey. Their 1990 hit "Joey" spent 21 weeks on the Billboard Top 100 Chart. 1989, Mike Sergieff (Order #124269)

Opposite: **Ratt.** Lead singer Stephen Pearcy energizes the crowd at the Los Angeles Sports Arena. 1989, Paul Chinn

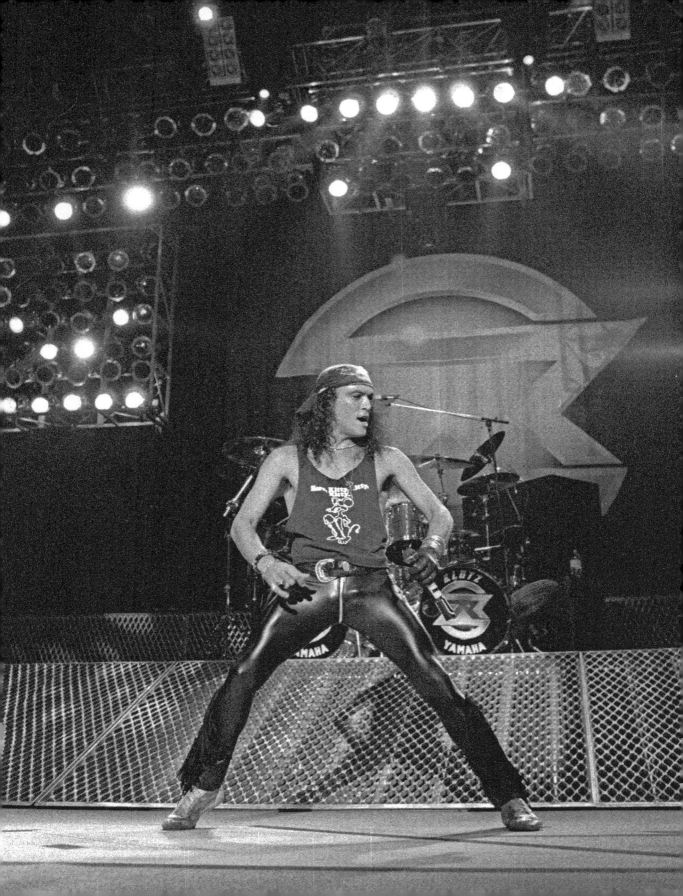

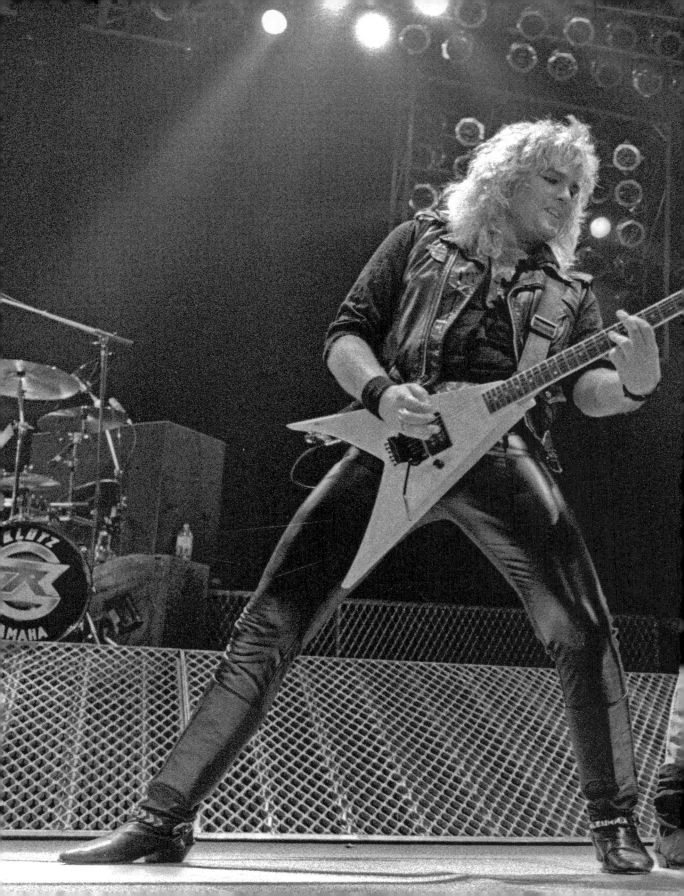

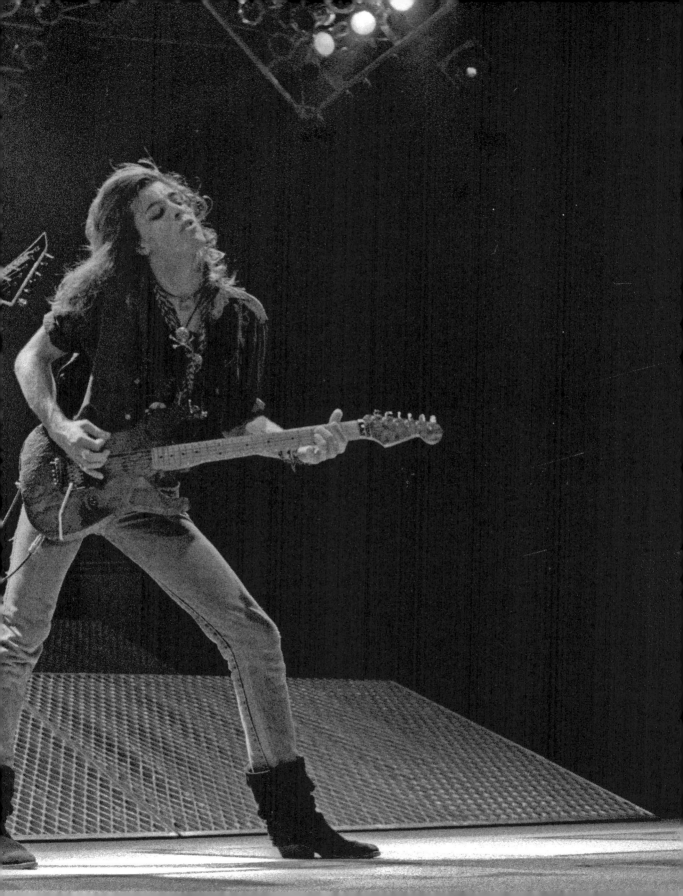

Slayer. Kerry King, Dave Lombardo, Jeff Hanneman and Tom Araya.
Thrash metal band from Orange County, Slayer attracted tremendous negative
attention from its depiction of satanic rituals and violence both lyrically and
visually, causing a backlash of outrage from retail stores, religious groups
and the mainstream public. Despite their notoriety, Slayer released ten studio
albums, four of which went gold, and were nominated for five Grammy awards,
winning two.
1984, James Ruebsamen (Order #121781)

Overleaf: **Ratt.** The dueling lead guitars of Robbin Crosby and Warren DeMartini
drove mid-1980s hits like "Round and Round" and "You're in Love."
1989, Paul Chinn

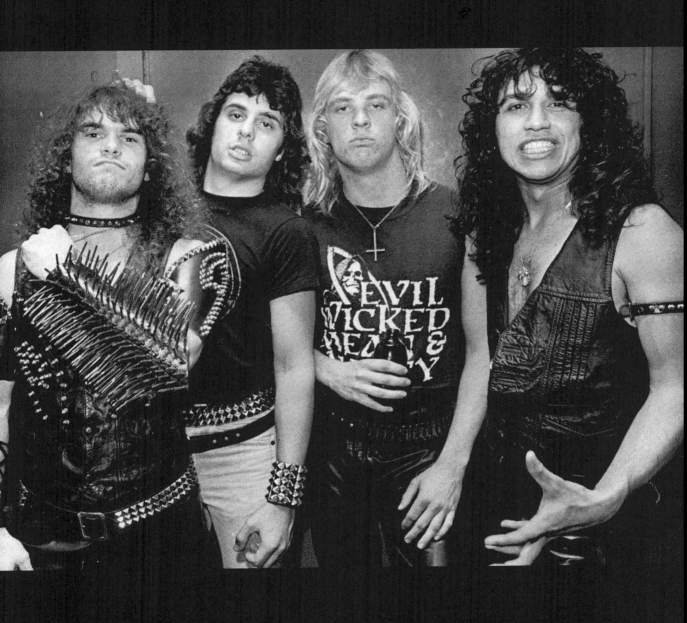

Black Flag. Left, Greg Ginn, founding member, guitarist and songwriter, and recent addition Henry Rollins, their fourth vocalist. Originating from Hermosa Beach, Black Flag found fame as one of the first Southern California hardcore punk bands, with shows attracting masses of fans as well as frequent raids from the LAPD.
ca 1984, Rob Brown (Order #121783)

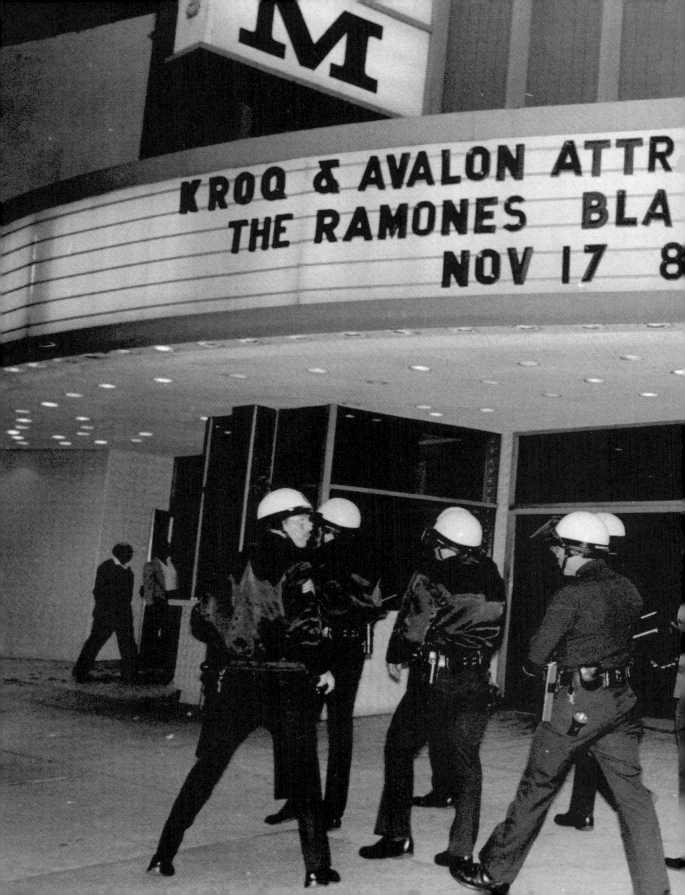

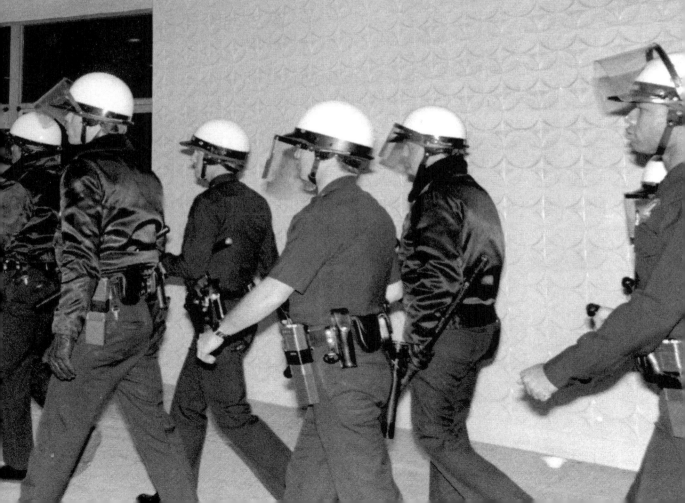

Castration Squad. Bass player Tiffany Kennedy of the all-female punk band Castration Squad.
ca 1981, Gary Leonard (Order #29438)

Overleaf: **Black Flag.** Police raid a Ramones and Black Flag concert at the Hollywood Palladium.
1980, Gary Leonard (Order #58818)

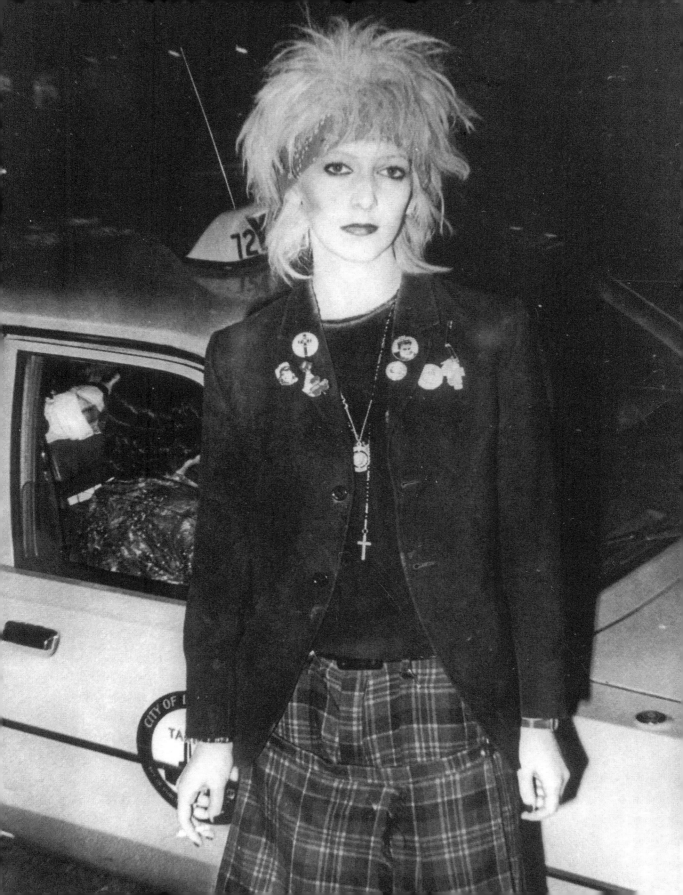

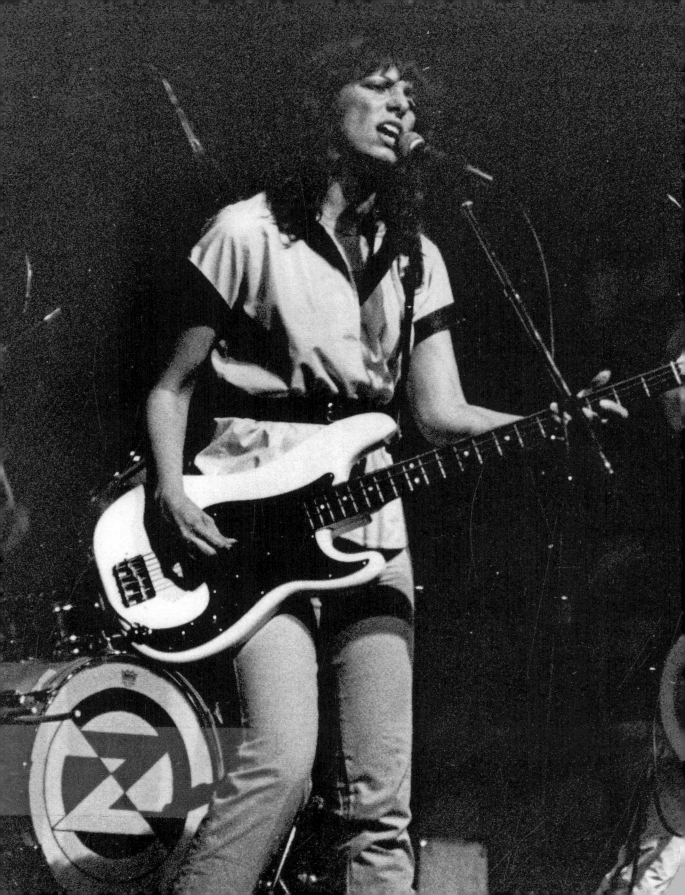

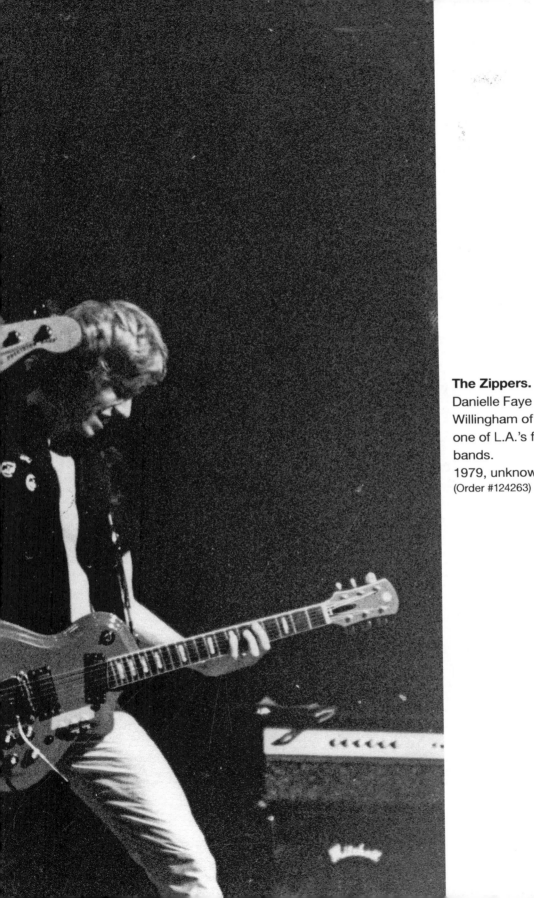

The Zippers. Bassist Danielle Faye and Bob Willingham of The Zippers, one of L.A.'s first punk bands.
1979, unknown
(Order #124263)

The Plugz. Plugz
guitarist Tito Larriva,
center, and artists
Richard Duardo and
Dan Segura at Zero Zero
Gallery.
1982, Gary Leonard
(Order #79318)

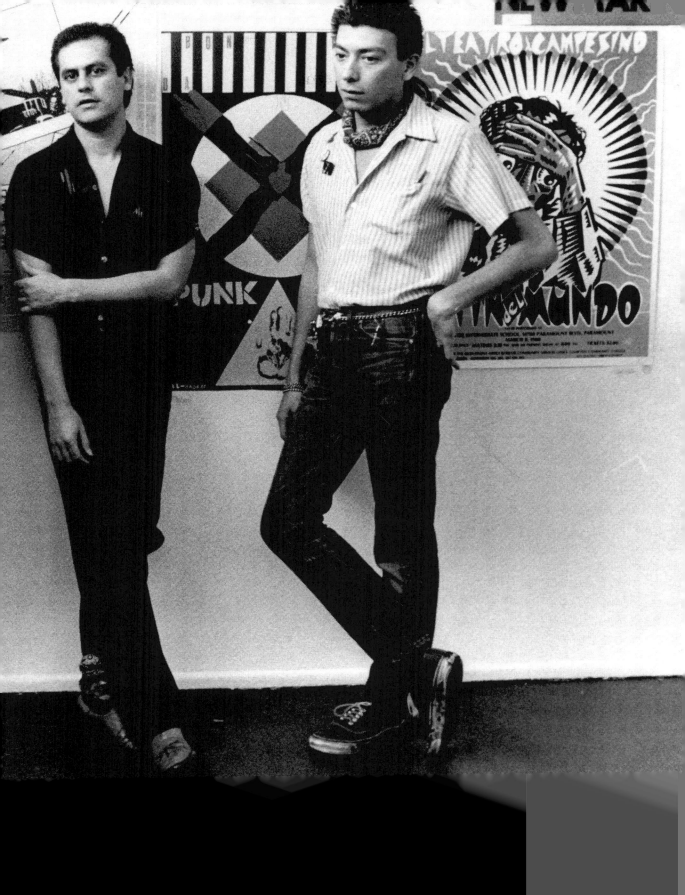

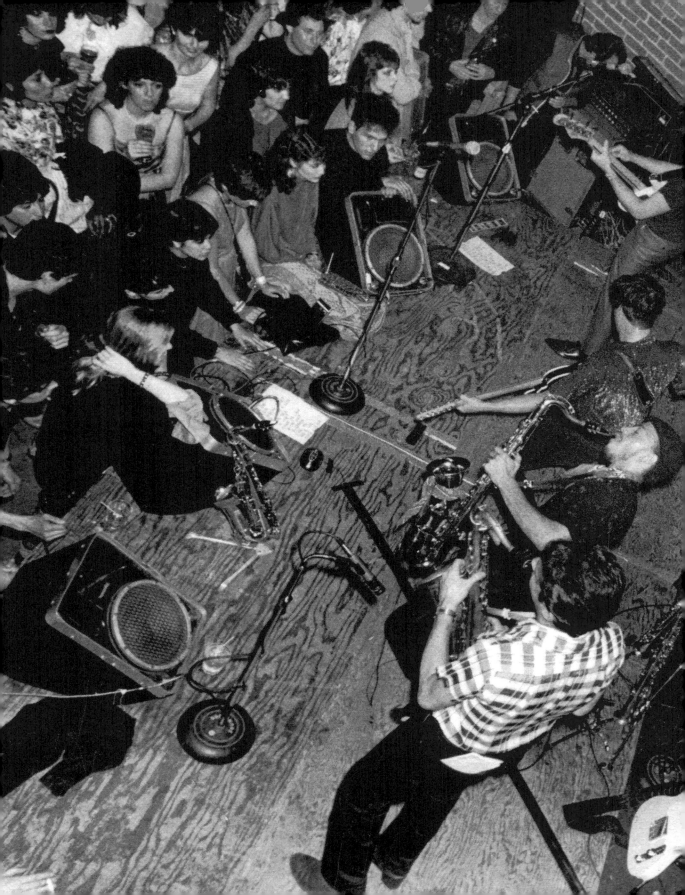

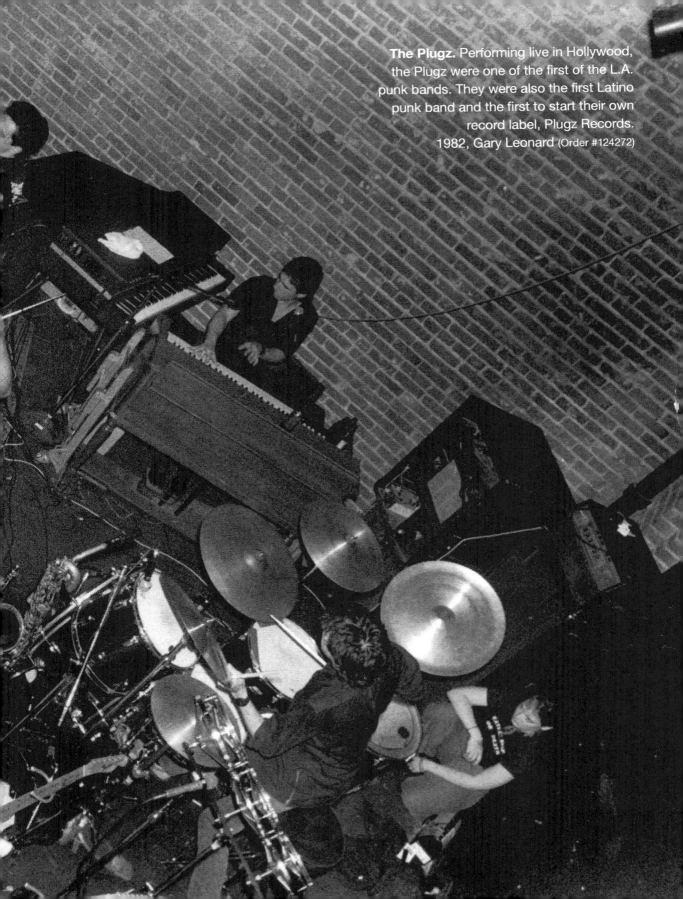

The Plugz. Performing live in Hollywood, the Plugz were one of the first of the L.A. punk bands. They were also the first Latino punk band and the first to start their own record label, Plugz Records. 1982, Gary Leonard (Order #124272)

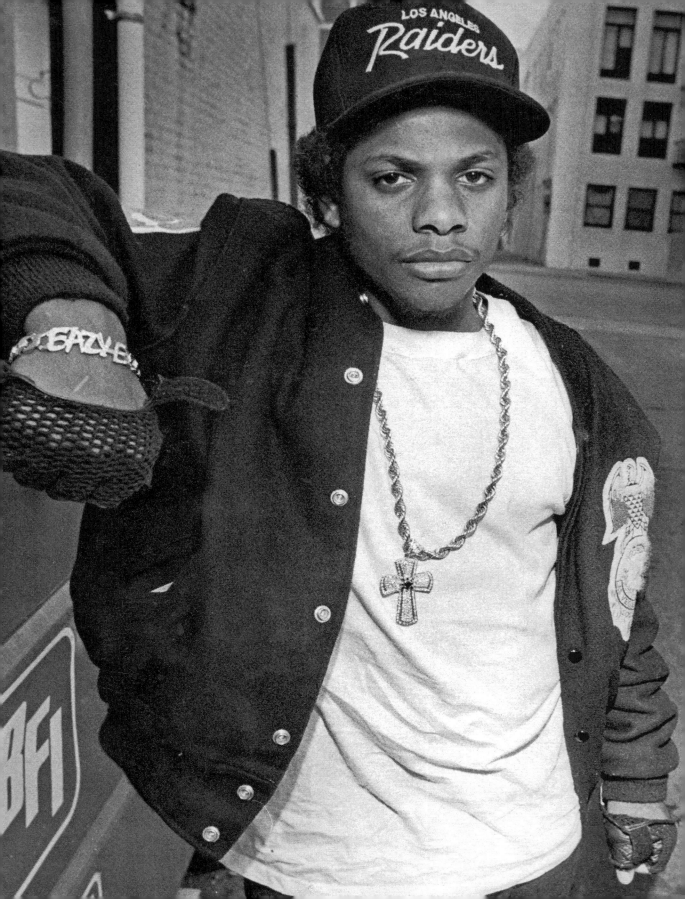

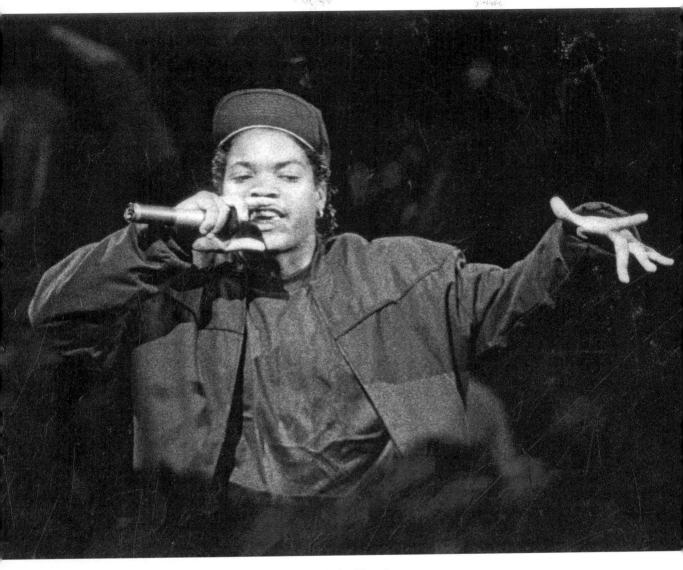

N.W.A. Ice Cube on stage at Anaheim Celebrity Theater.
1989, Steve Grayson (Order #124264)

Opposite: **N.W.A.** Eazy-E, born Eric Wright, was also known as The Godfather of "Gangsta Rap," performed both as a solo artist and with L.A. rappers Ice Cube and Dr. Dre in the hip hop group N.W.A. The highly controversial album *Straight Outta Compton,* released on Eazy-E's label Ruthless Records, reached a remarkable double platinum status, despite a lack of radio airplay.
1989, Steve Grayson (Order #121785)

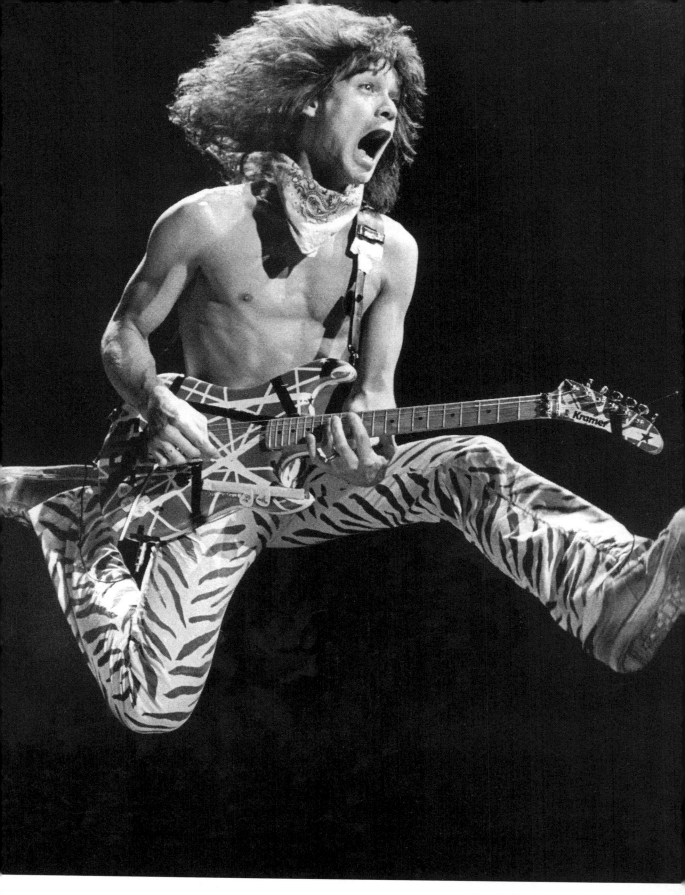

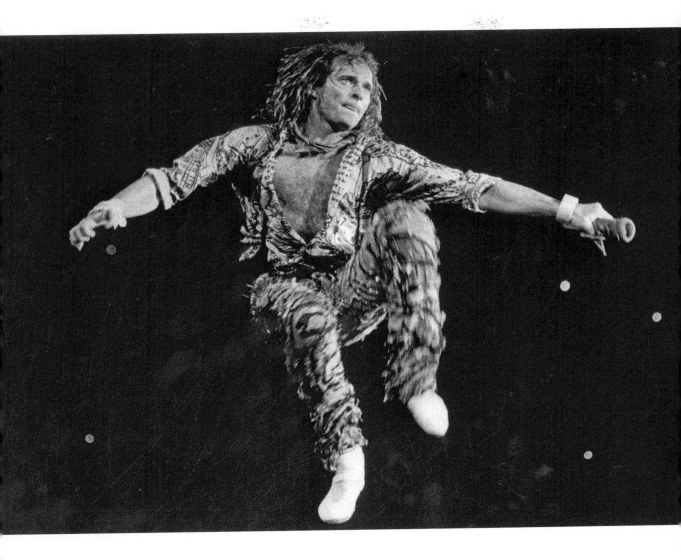

Van Halen. Lead singer David Lee Roth onstage at the Forum.
1984, Paul Chinn (Order #124251)

Opposite: **Van Halen.** Lead guitarist Edward Van Halen in mid-leap onstage
at the Los Angeles Forum. One of the most successful rock acts of all time,
Van Halen got their start at high school dances and the Sunset Strip clubs
Gazzari's and the Whisky a Go Go.
1984, Paul Chinn (Order #121776)

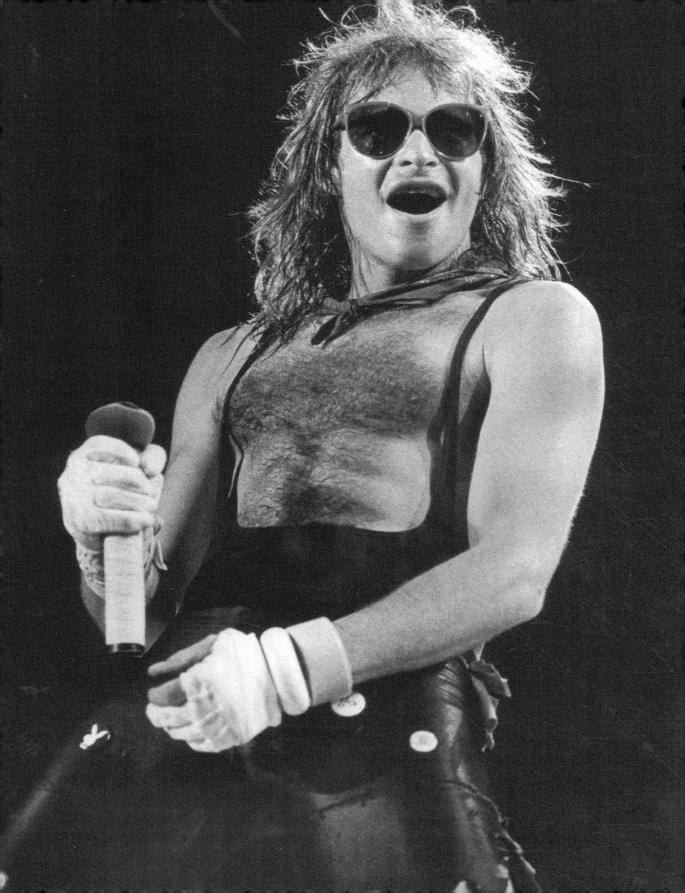

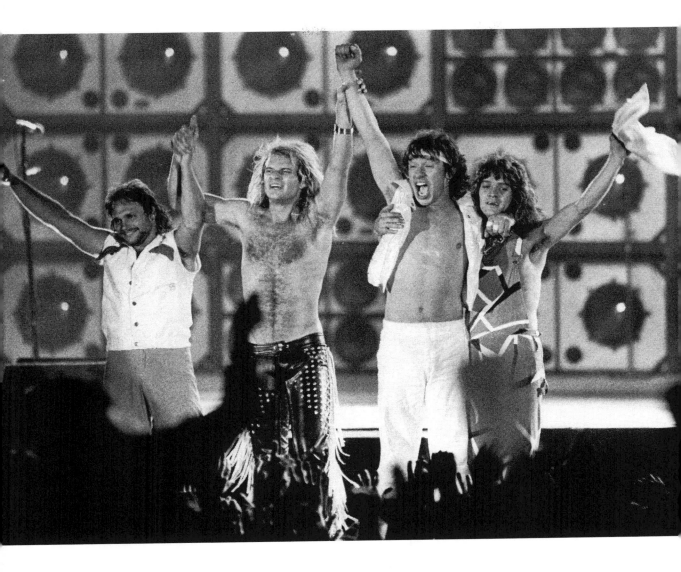

Van Halen. Michael Anthony, David Lee Roth, Alex Van Halen and Eddie Van Halen, triumphant at the close of one of their sold-out shows. ca 1984, James Ruebsamen (Order #124252)

Opposite: **Van Halen.** Lead singer David Lee Roth onstage at the Forum. 1984, Paul Chinn (Order #124253)

The Dickies. Lead singer Leonard Phillips, silhouetted against a flurry of tiny styrofoam balls from a gutted bean bag, creates a synthetic winter wonderland during a rendition of "Silent Night" at the Country Club. The Dickies were one of L.A.'s most popular punk bands, injecting their rapid-fire numbers with zany theatricality.
1989, Todd Everett (Order #121778)

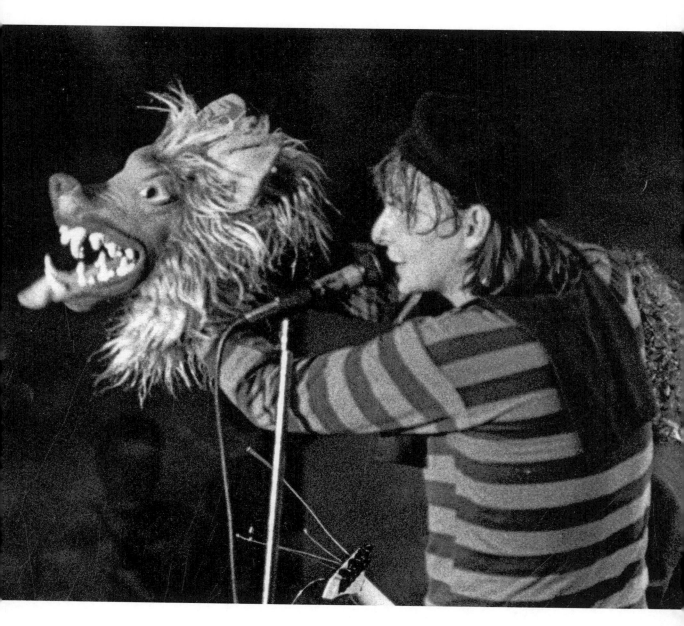

The Dickies. Lead singer Leonard Phillips with one of his stage props.
1989, Todd Everett (Order #124282)

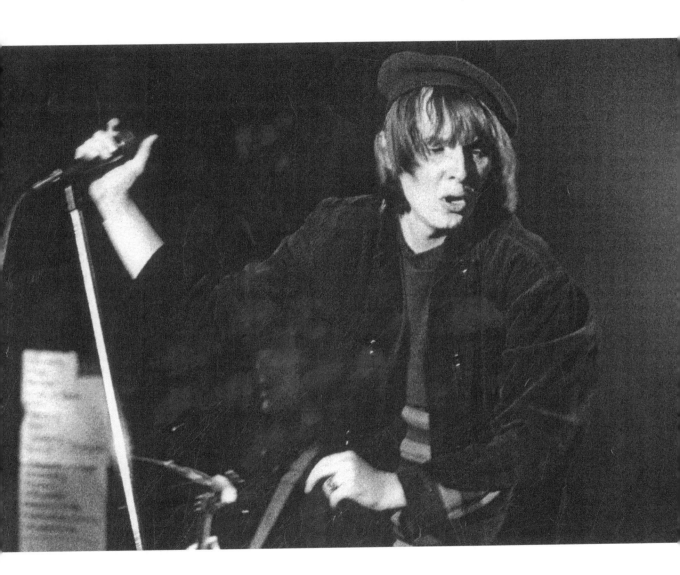

The Dickies. Lead singer Leonard Phillips on stage at The Country Club. 1989, Todd Everett (Order #124283)

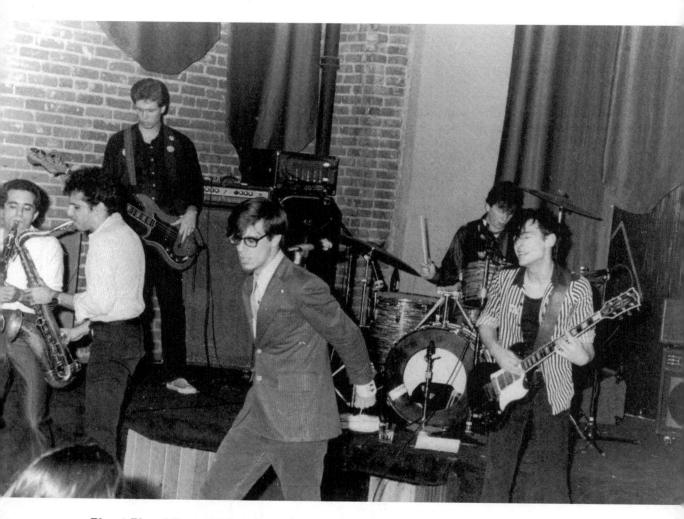

Phast Phreddie and Thee Precisions. Steve Berlin, Don Snowden, Phast Phreddie, Chris Bailey, Harlan Hollander.
1981, Gary Leonard (Order #29381)

Opposite: **Fred (Phast Phreddie) Patterson.** Editor of the music magazine *Back Door Man*, Fred was one of the first to cover the L.A. music scene of the 70's and '80s.
1981, Gary Leonard (Order #29921)

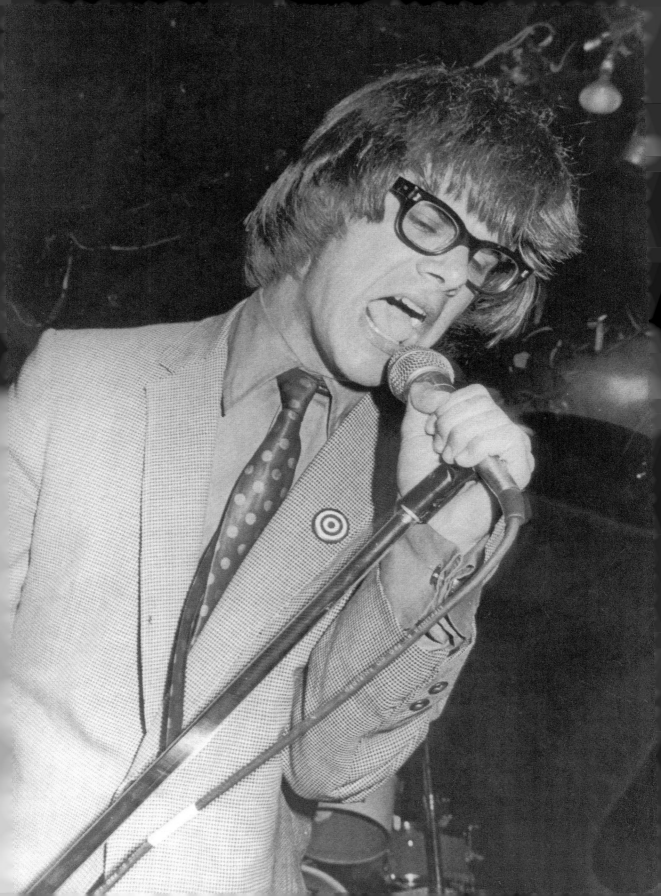

The Bangles. Vicki Peterson, Annette Zilinskas, Susanna Hoffs and Debbi Peterson. Influenced by L.A. 60s legends The Byrds and The Buffalo Springfield, The Bangles set themselves apart from other all-female bands of the era. Their blend of sixties-influenced folk rock and melodic vocal harmonies gained them major commercial and critical success with songs "Walk Like An Egyptian" and "Manic Monday."
1983, Michael Edwards (Order #121782)

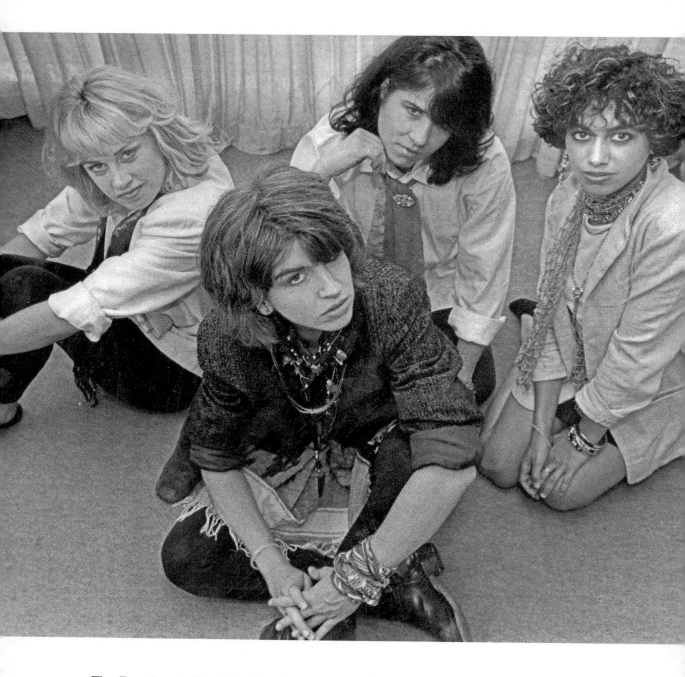

The Bangles. Left to right: Debbi Peterson, Michael Steele, Vicki Peterson, Susanna Hoffs.
1984, James Ruebsamen (Order #124256)

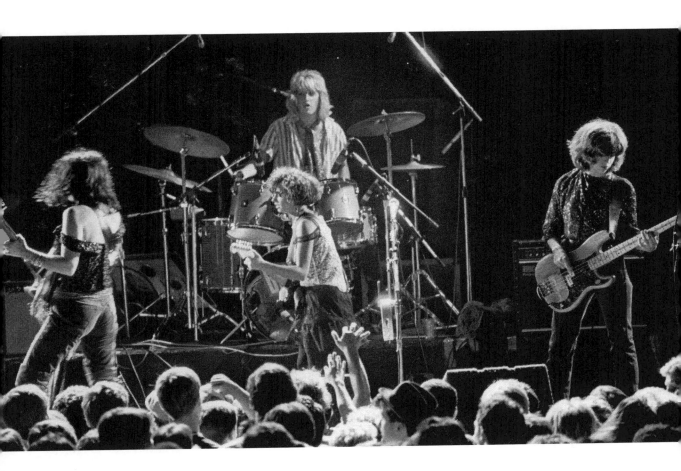

The Bangles. The Bangles play the Palace.
1984, Leo Jarzomb (Order #124257)

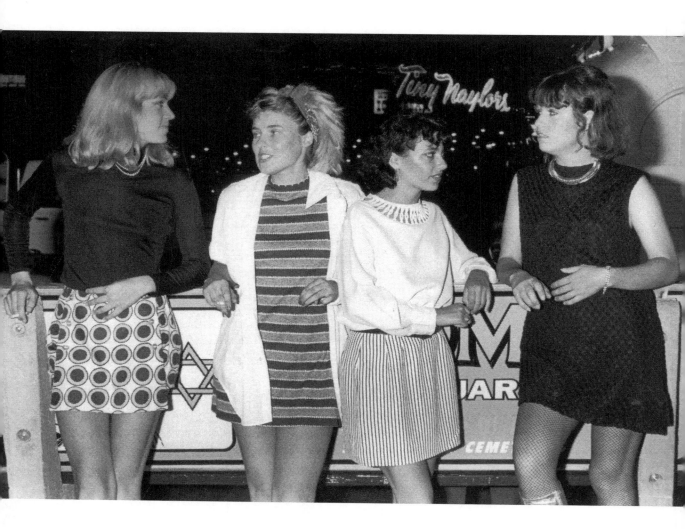

The Bangles. Debbi, Annette, Susanna and Vicki.
1982, Gary Leonard (Order #124276)

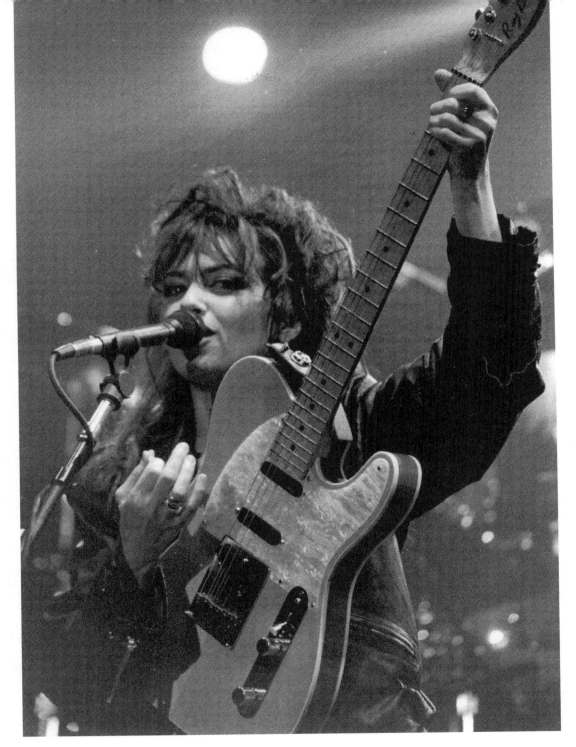

The Bangles. Lead singer Susanna Hoffs at the Santa Monica Civic.
1989, Lucy Snowe (Order #124275)

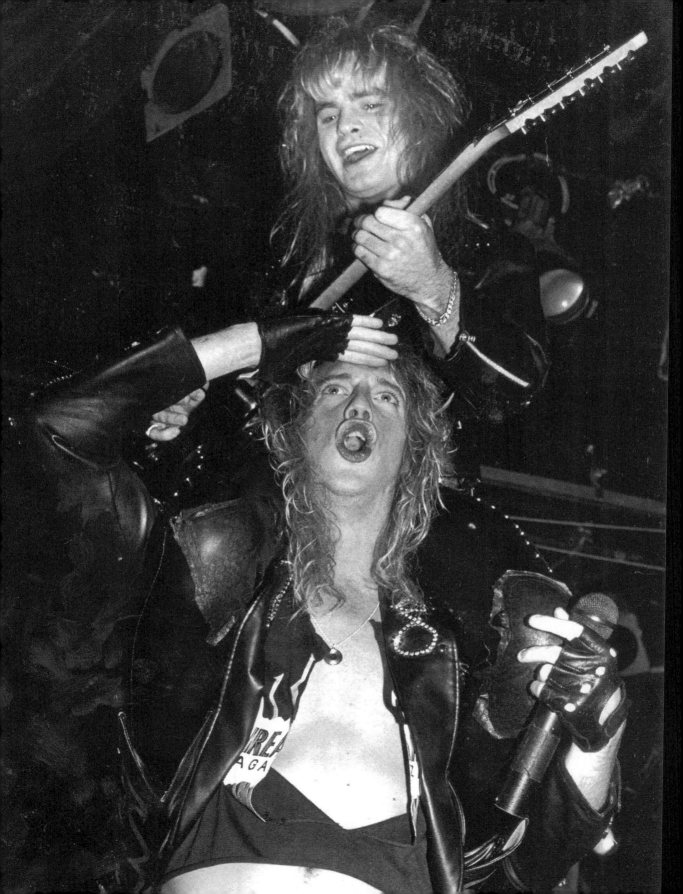

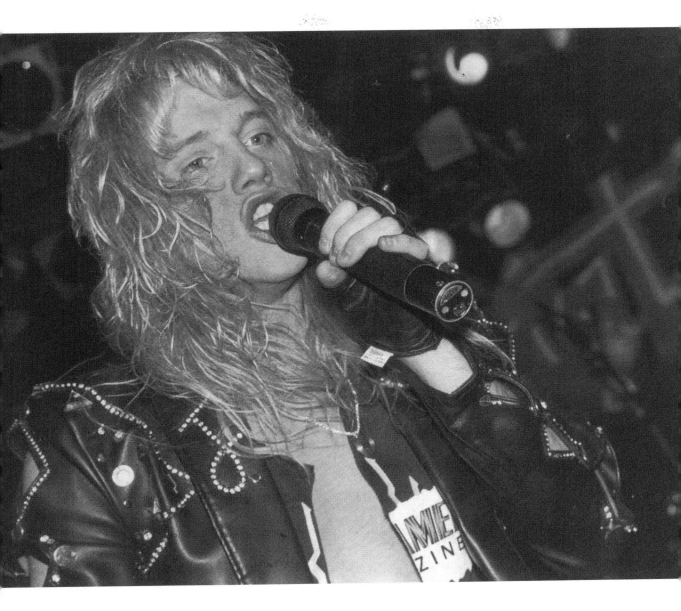

Warrant. Lead singer Jani Lane.
1989, Lucy Snowe (Order #124277)

Opposite: **Warrant.** Lead singer Jani Lane and guitarist Joey Allen on stage at the Roxy. Before signing with Columbia Records and releasing their mega-hit debut album *Dirty Rotten Filthy Stinking Rich,* Warrant was a fixture in the L.A. club scene.
1989, Lucy Snowe (Order #54885)

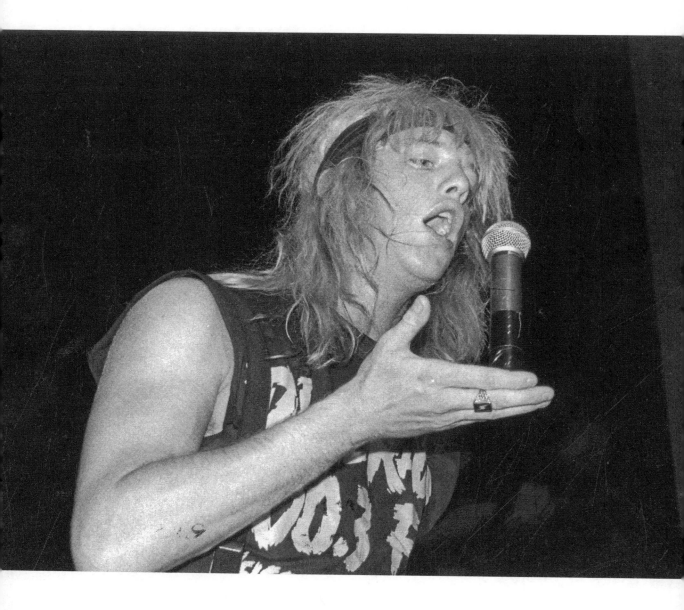

Warrant. Jani Lane at the Universal Amphitheatre.
1989, Todd Everett (Order #124278)

Opposite: **Warrant.** Jani Lane and Jerry Dixon at the Universal Amphitheatre.
1989, Todd Everett (Order #124279)

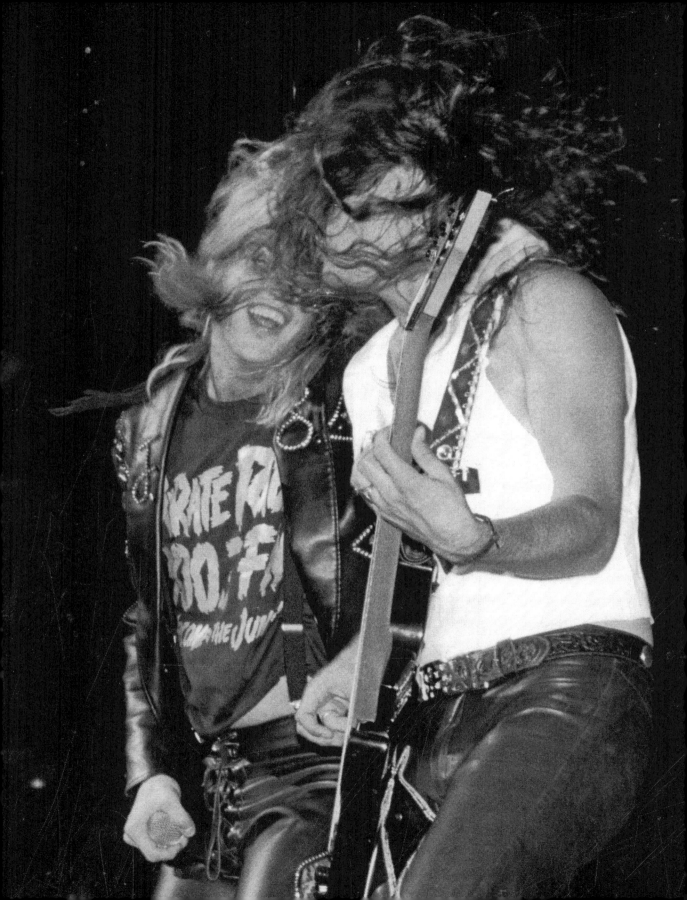

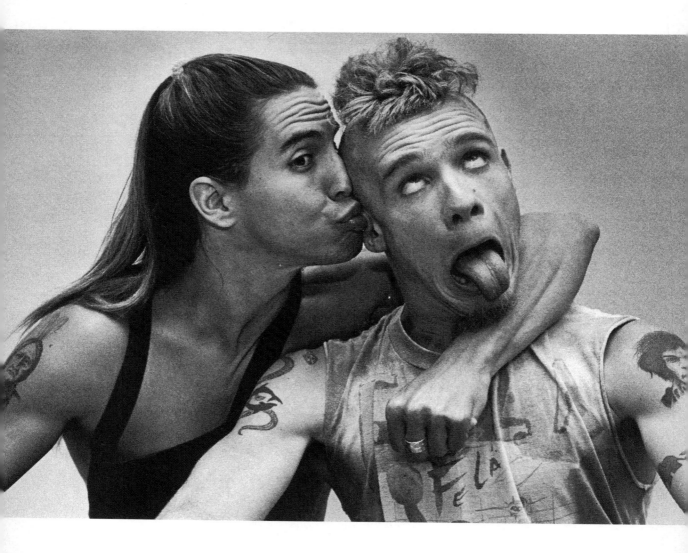

Red Hot Chili Peppers. Singer Anthony Kiedis, left and bassist Flea. Driven by throbbing bass lines and funky rhythms, their live shows often featured elements of improvisation and humor. They have won seven Grammy Awards and in 2012, were inducted into the Rock and Roll Hall of Fame.
1989, James Ruebsamen (Order #121779, #124281 opposite)

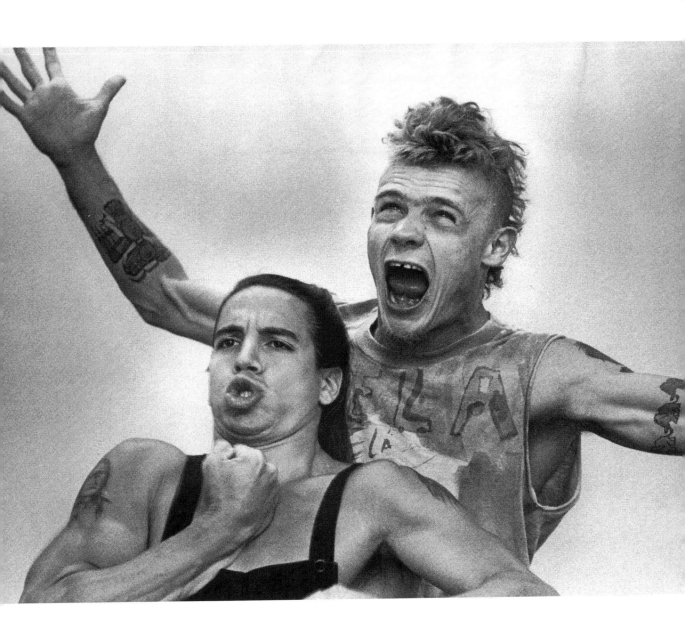

Red Hot Chili Peppers. Live at the Palladium.
1989, Lucy Snowe (Order #124280)

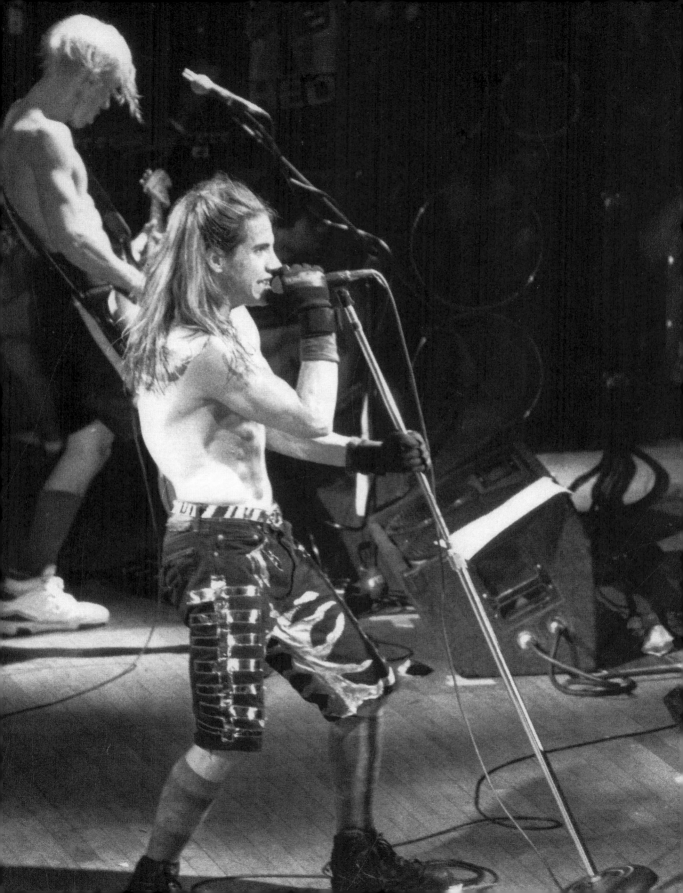

The Three O'Clock. Mike Mariano, Jason Faulkner, Danny Benair, Michael Quercio. The Sixties-influenced breakout band, known for jangly guitars, psychedelic pop melodies and dreamy vocals led the Paisley Underground scene in the early 1980s.
1988, Mike Mullen (Order #121789)

Opposite: **The Three O'Clock.** Louis Gutierrez, Michael Quercio, Danny Benair and Mike Mariano.
ca 1984, Paul Chinn (Order #124288)

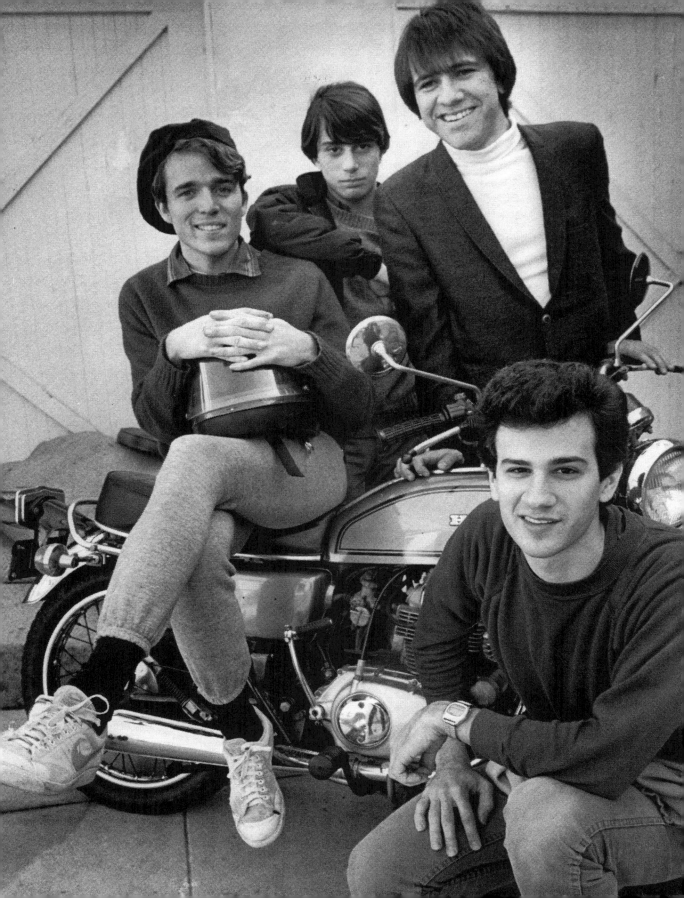

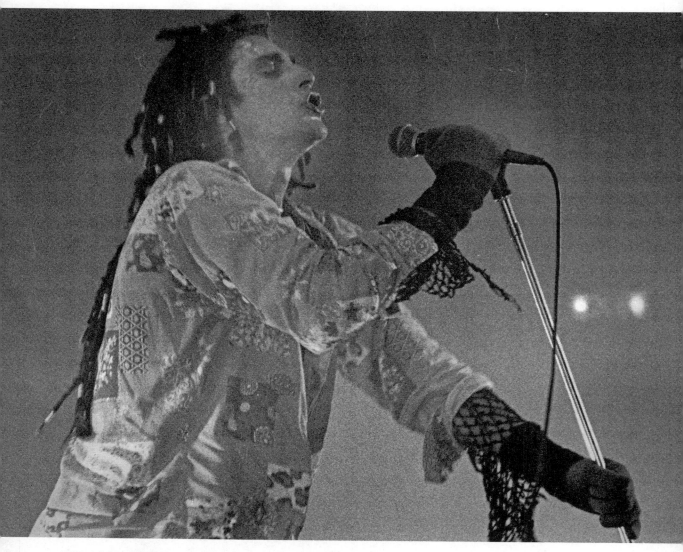

Jane's Addiction. Lead singer Perry Farrell performs at the John Anson Ford Theater. The band is credited with being pioneers of the Alternative Rock genre and for launching the Lollapalooza concert series in 1991. Considering their albums were released by an independent label, their success was extraordinary, and hits such as "Jane Says" and "Been Caught Stealing" continue to be mainstays on alternative radio playlists. 1989, Lucy Snowe (Order #121790)

Opposite: **Jane's Addiction.** Live at the John Anson Ford Theater. 1989, Lucy Snowe (Order #24274)

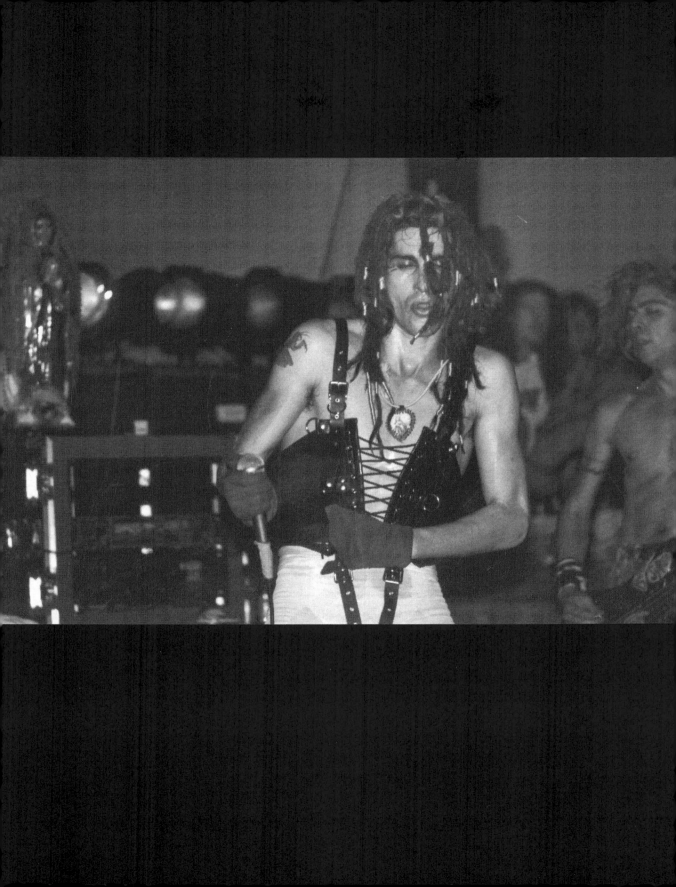

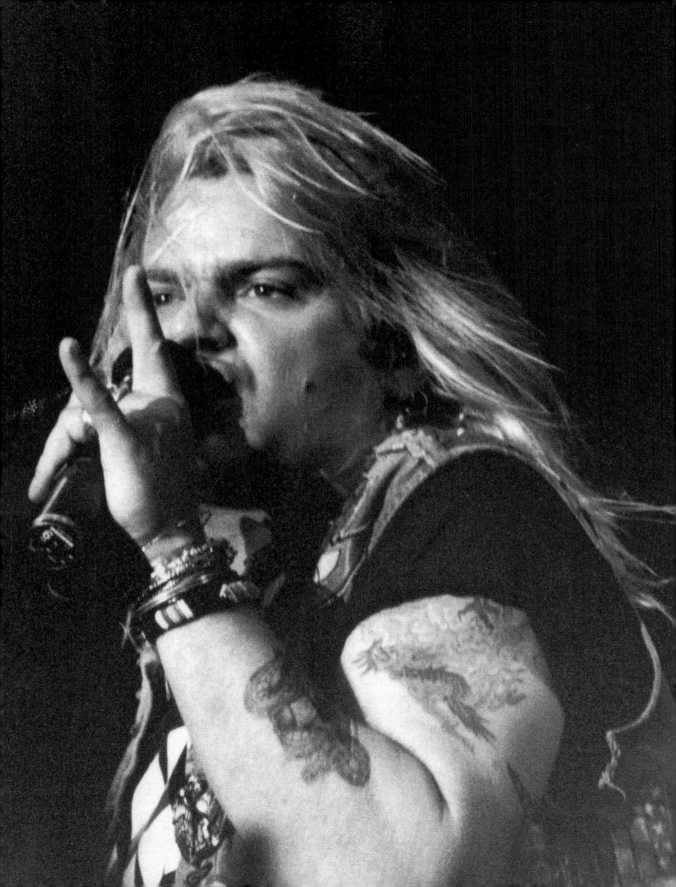

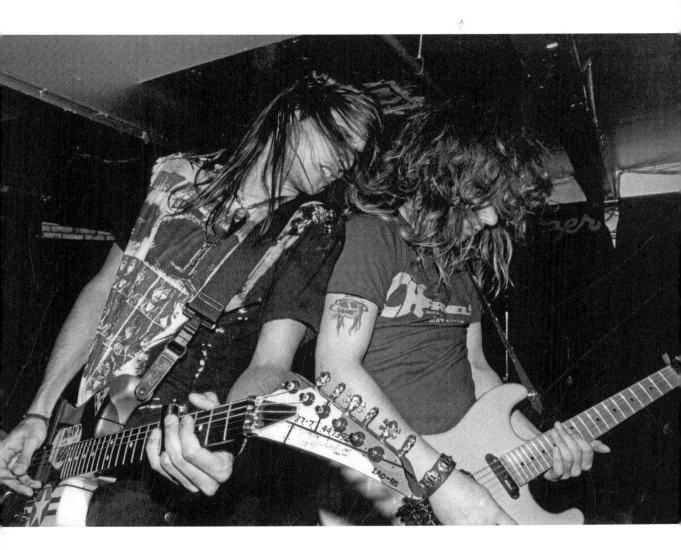

Jailhouse. Guitarist Amir Derakh formerly of Rough Cutt, plays alongside Michael Raphael. 1989, Lucy Snowe (Order #124267)

Opposite: **Junkyard.** Lead singer David Roach headed this rock/punk/country/ blues band that achieved moderate success at Geffen Records with tracks like "Hollywood" and "Simple Man."
1989, Lucy Snowe (Order #124266)

Dream Syndicate. Steve Wynn, Karl Precoda, Dennis Duck.
1984, Anne Knudsen (Order #124255)

Overleaf: **Dream Syndicate.** Karl Precoda, Kendra Smith, Dennis Duck, Steve
Wynn. Another of the Paisley Underground bands of the 80s, Dream Syndicate
were frequent headliners in the Los Angeles club scene and were highly
regarded by music critics for their songwriting and live shows.
1982, Dean Musgrove (Order #121780)

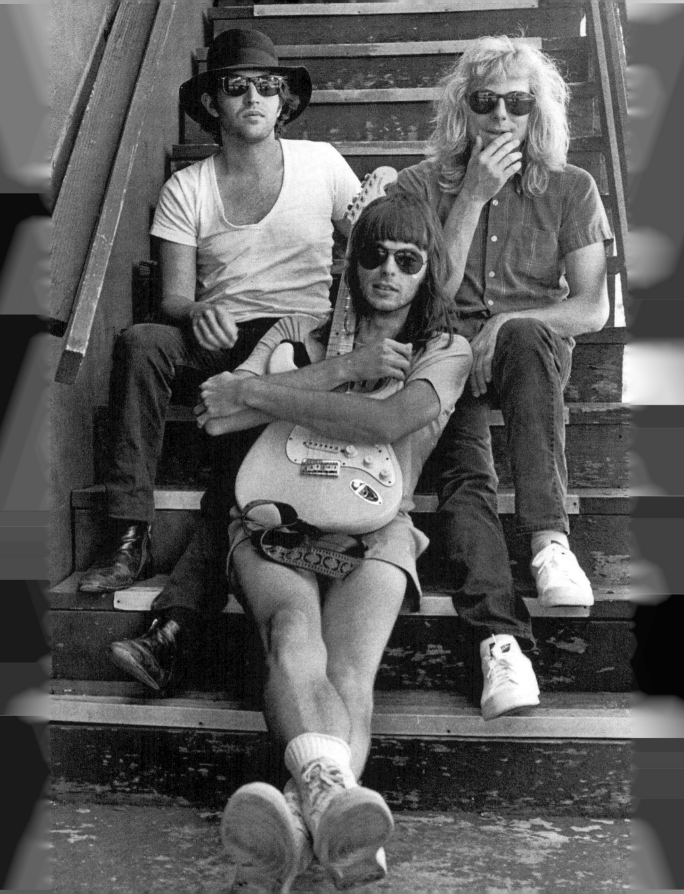

Dream Syndicate. Karl Precoda and
Steve Wynn with their gold records.
1984, Toru Kawana (Order #124254)

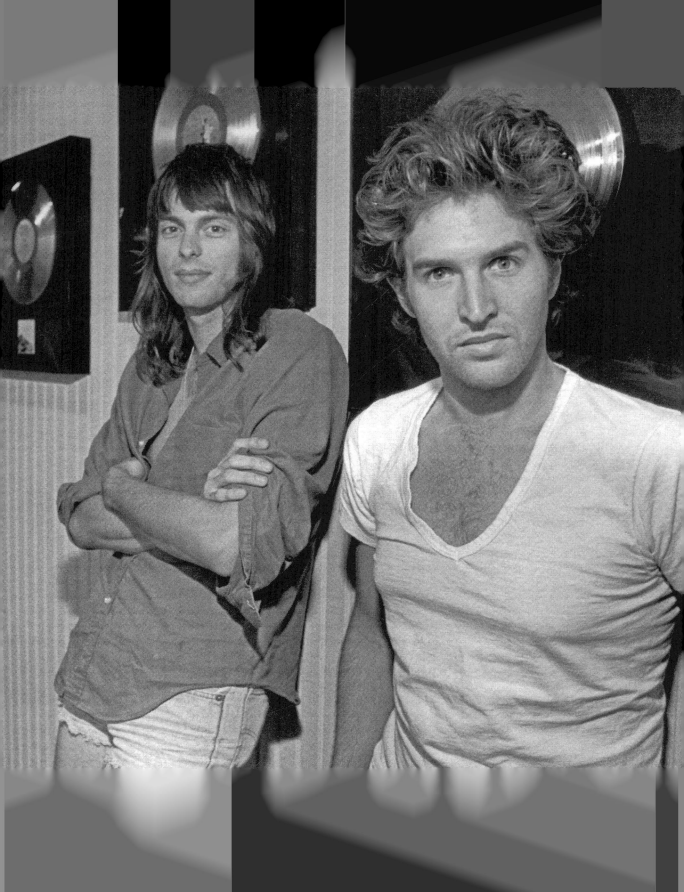

Redd Kross. Formed in the late 1970s by preteen McDonald brothers Steven, left and Jeff, right, their first recording sessions were financed by their paper routes. Originally part of the early L.A. punk scene, their music evolved into 70s-inspired bubblegum pop, or as they refer to their sound, "Hawthorne California Trash Rock." The band still tours and currently includes drummer Roy McDonald and guitarist Jason Shapiro.
1989, Lucy Snowe (Order #121769)

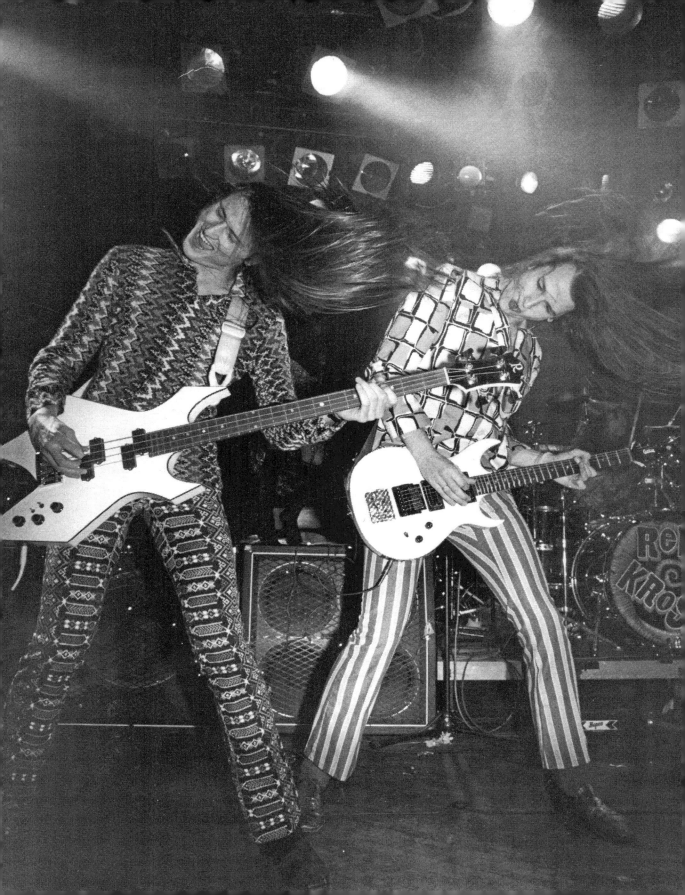

Celebrity Skin. Jason Shapiro, lead guitarist, performing at Raji's. One of the most theatrical and entertaining of the alternative rock bands of the '80s, known as much for their strikingly imaginative stage costumes and props as for their unique rock sound. 1989, Lucy Snowe (Order #121766)

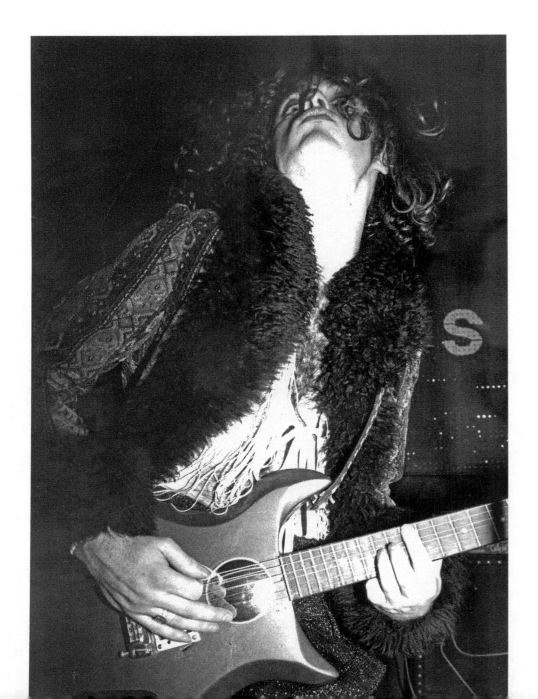

Quiet Riot. Devoted fans congregate in front of CBS Records Los Angeles headquarters, demanding a record contract for Quiet Riot. The spectacle made the papers, but was not enough for the label to take action this time around. The band broke up soon afterwards, and guitarist Randy Rhoads left to make history with Ozzy Osbourne. The band reformed without Rhoads, and CBS finally signed Quiet Riot in 1982. A year later their album *Metal Health* reached the top of the Billboard chart. 1979, Ken Papaleo (Order #121770)

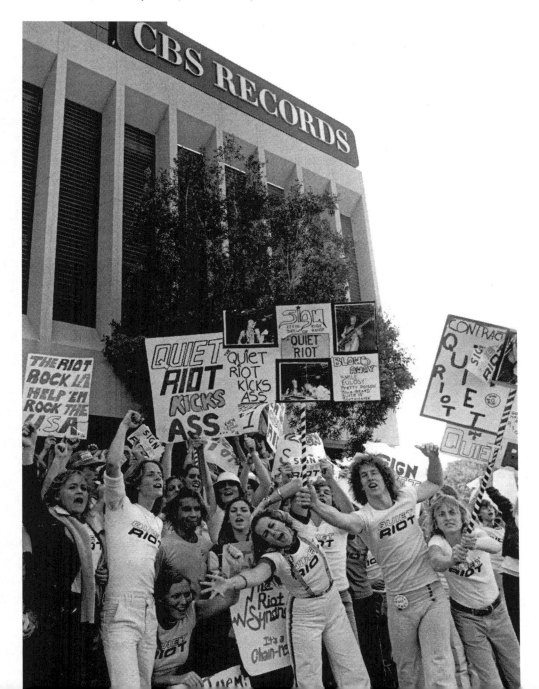

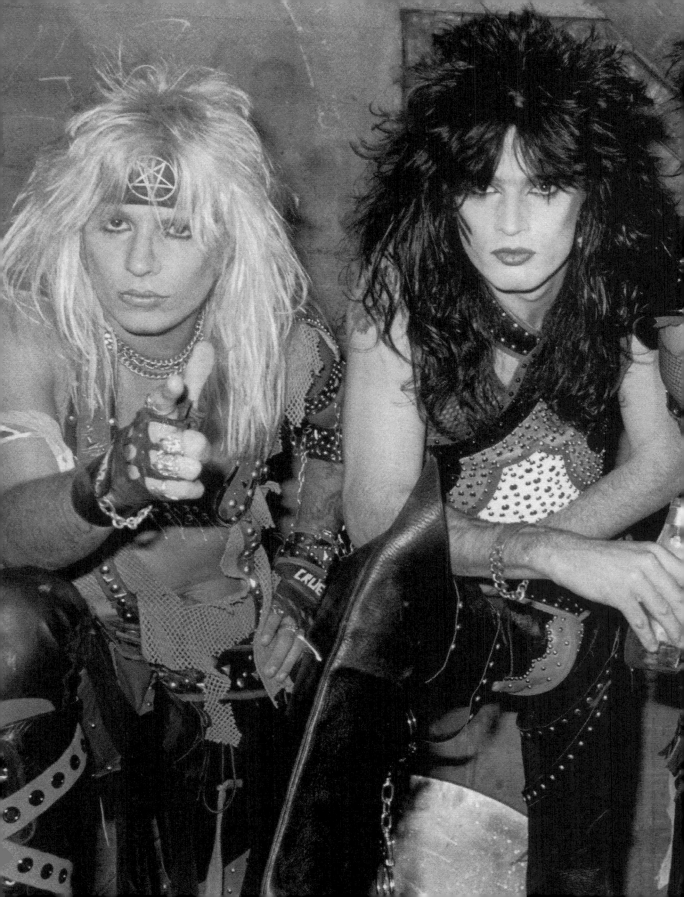

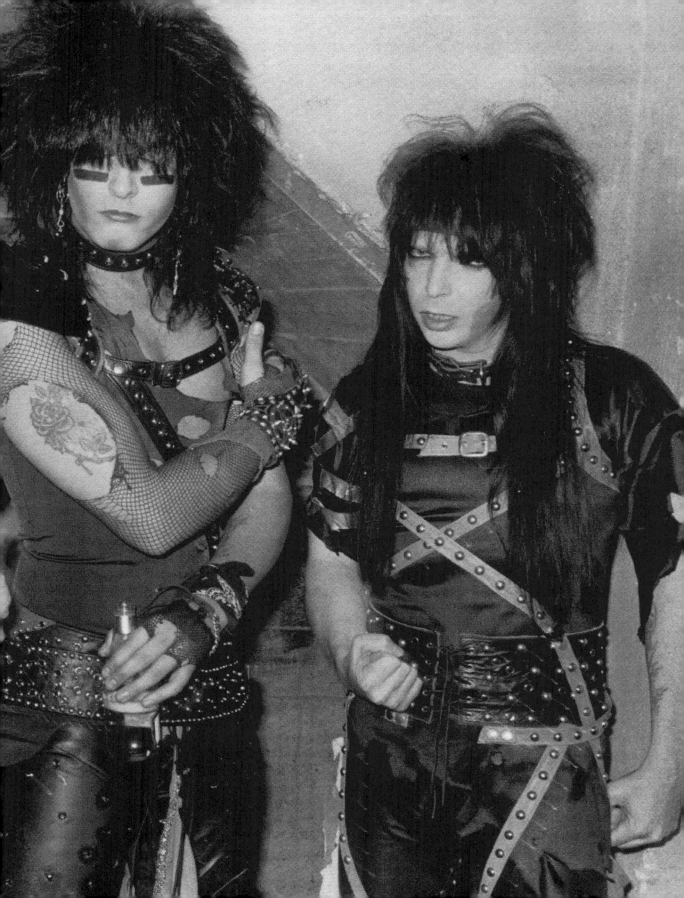

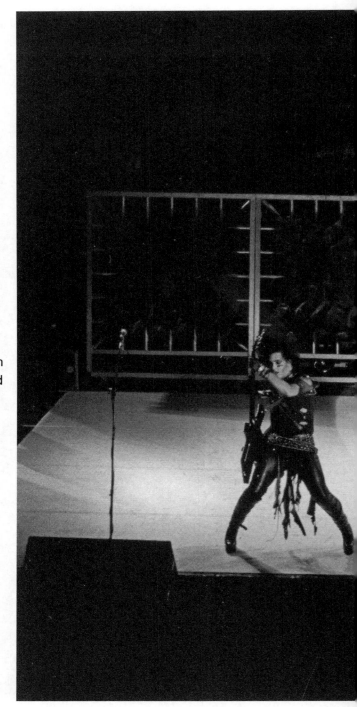

Mötley Crüe. The band rehearses at Perkins Palace the for their upcoming show at the Santa Monica Civic. 1983, Gary Leonard (Order #121775)

Overleaf: **Mötley Crüe.** Vince Neil, Tommy Lee, Nikki Sixx, Mick Mars. Donning war-paint and ready to take on the world in this previously unpublished portrait, Mötley Crüe led the first of the wave of 1980s heavy metal bands on the Sunset Strip, and were the first to achieve major national success. 1983, Gary Leonard (Order #121774)

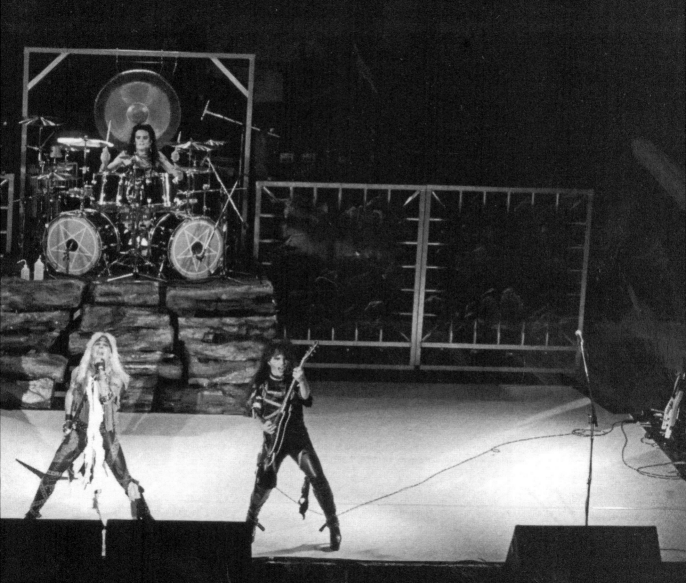

**Top Jimmy
and El Duce.**
James Paul
Koncek, A.K.A.
Top Jimmy of
Top Jimmy and
the Rhythm Pigs
poses in front
of the Cathay
de Grand night
club; in the
background with
the bulging belly
is the late Eldon
Hoak, A.K.A.
El Duce of The
Mentors.
ca 1984,
Gary Leonard
(Order #29465)

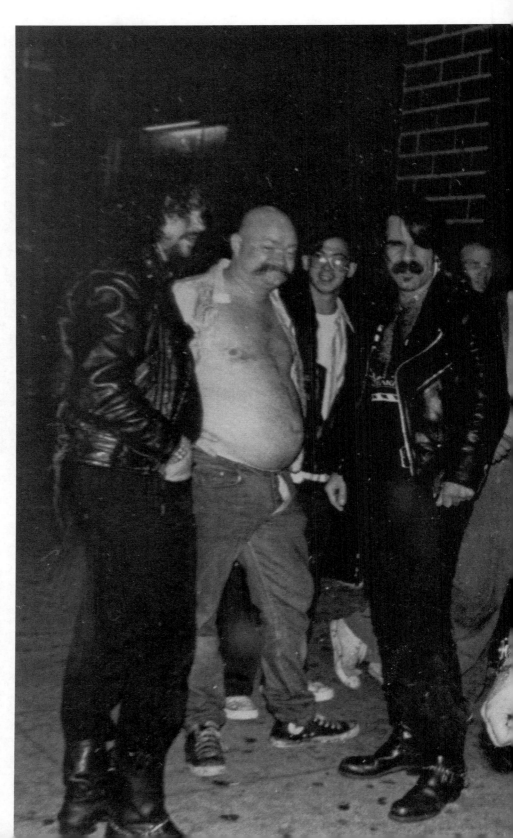

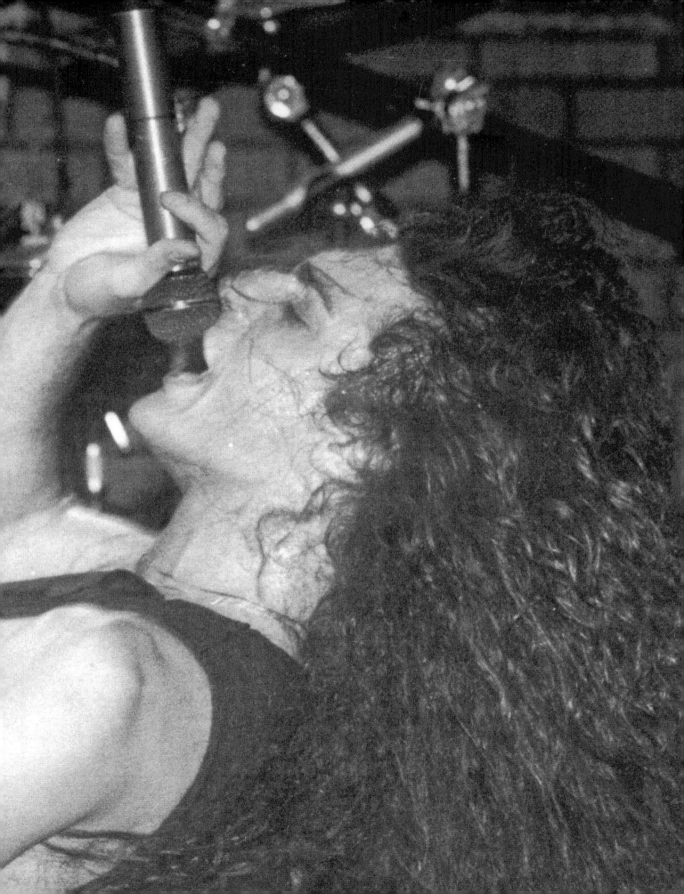

Brunette. Not a single blonde among them, Brunette entertain their fans.
1989, Lucy Snowe (Order #124289)

Overleaf: **Brunette.** Lead singer Johnny Gioeli at the Troubador. With his brother Joey, Gioeli later teamed up with former Journey guitarist Neal Schon to form the band Hardline.
1989, Todd Everett (Order #124290)

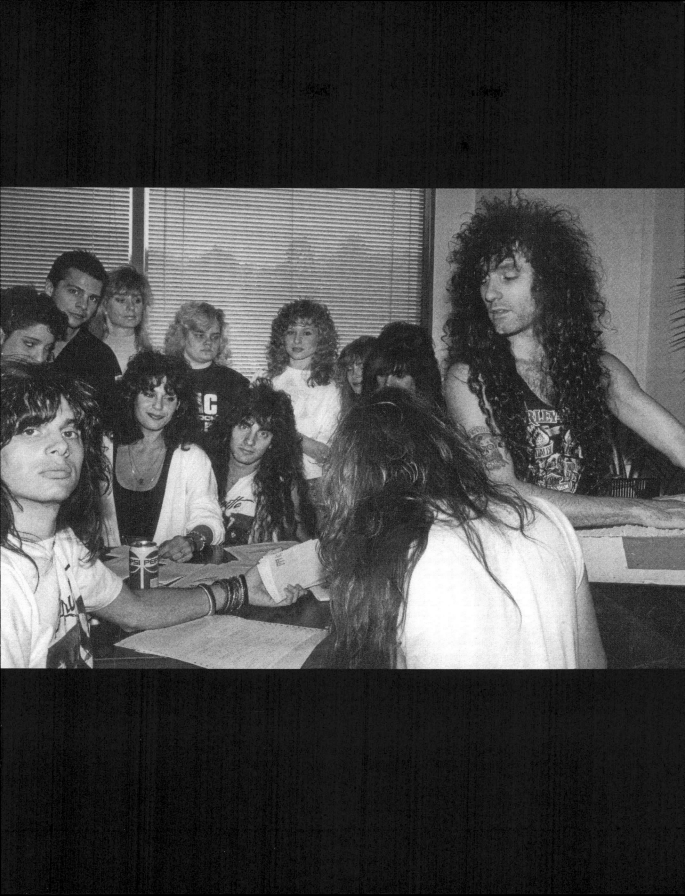

Oingo Boingo. Originally a musical theater troupe named The Mystical Knights of the Oingo Boingo, they scaled down both the name and their members in the 1980s, performing eclectic, new wave rock featuring horns and synthesizers to create a full orchestral sound that defies description.
1983, Michael Edwards (Order #121791)

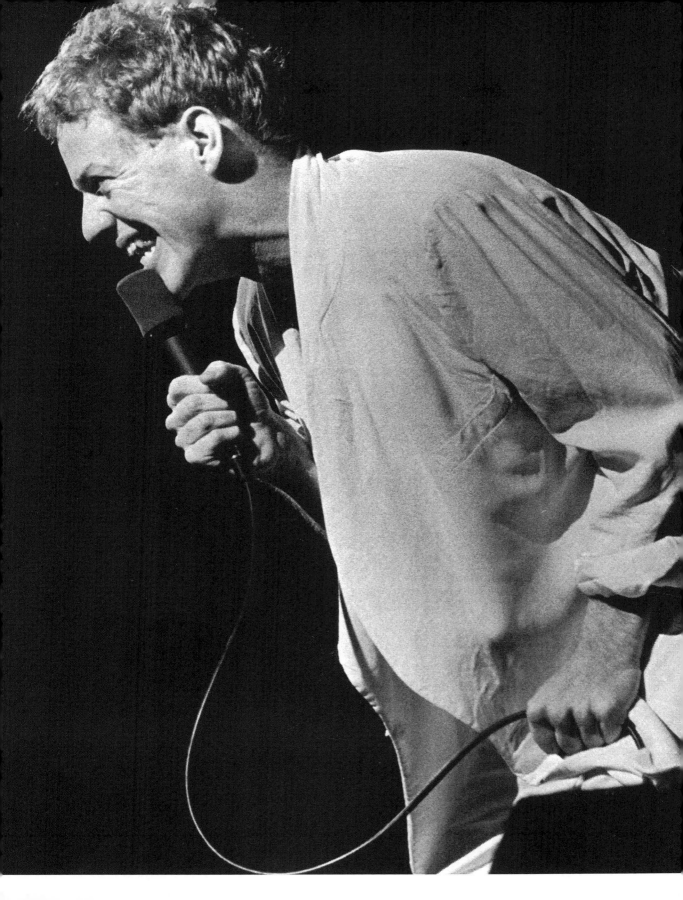

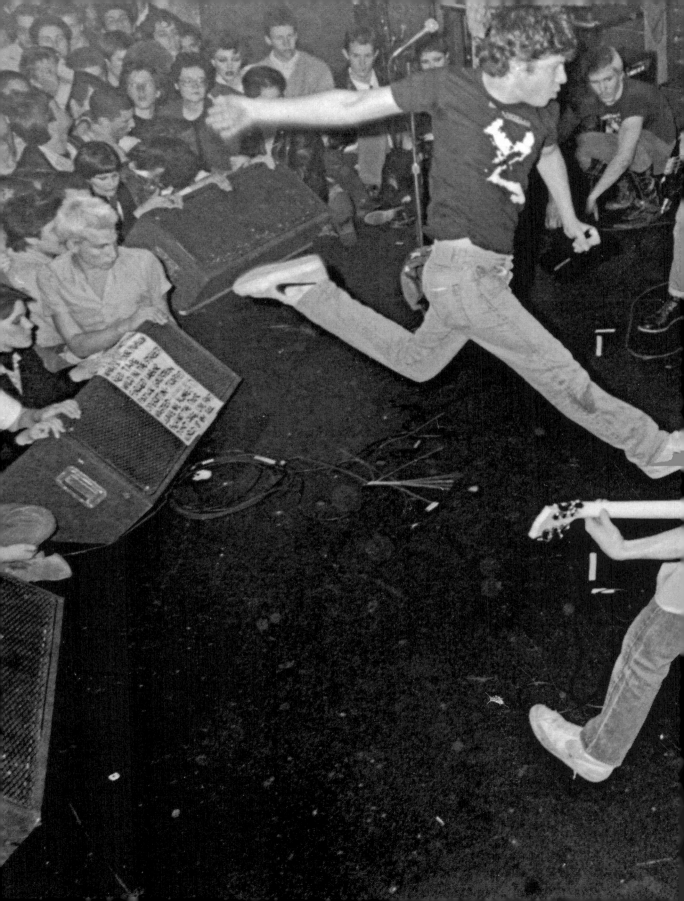

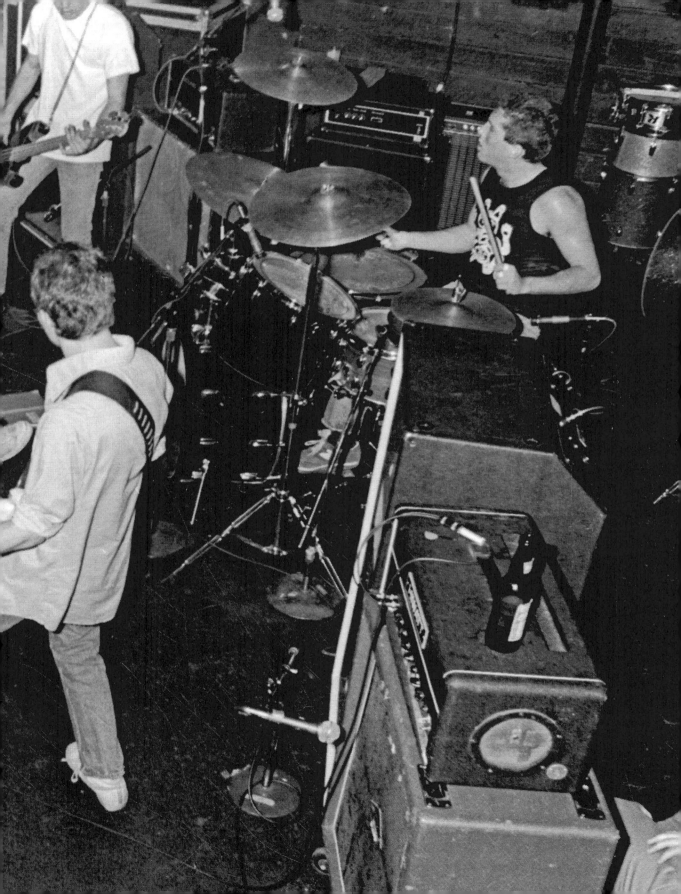

El Vez. Robert Lopez, formerly of early L.A. punk band The Zeros, with the Elvettes. El Vez performs classic rock with a Latin American flair, paying tribute to artists such as Elvis Presley, David Bowie, Marc Bolan and Freddie Mercury.
1989, Lucy Snowe (Order #54867)

Overleaf: **The Circle Jerks.** Preeminent hardcore punk band The Circle Jerks (Keith Morris, Greg Hetson, Roger Rogerson, Lucky Lehrer) on stage at the Starwood night club.
1981, Gary Leonard (Order #58814)

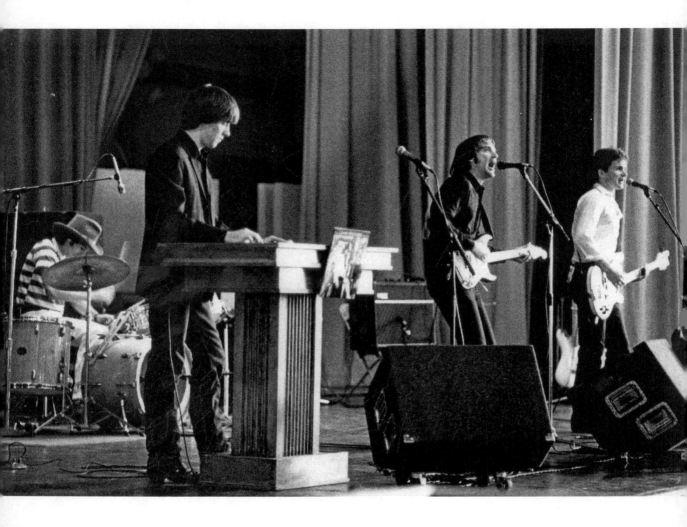

The Long Ryders. Greg Sowders, Sid Griffin, Stephen McCarthy and Tom Stevens make up the Paisley Underground Long Ryders.
ca 1984, Rob Brown (Order #124258)

Opposite: **Rain Parade.** Matt Piuci and David Roback, another of the Paisley Undergound bands of Los Angeles.
1983, Rob Brown (Order #124259)

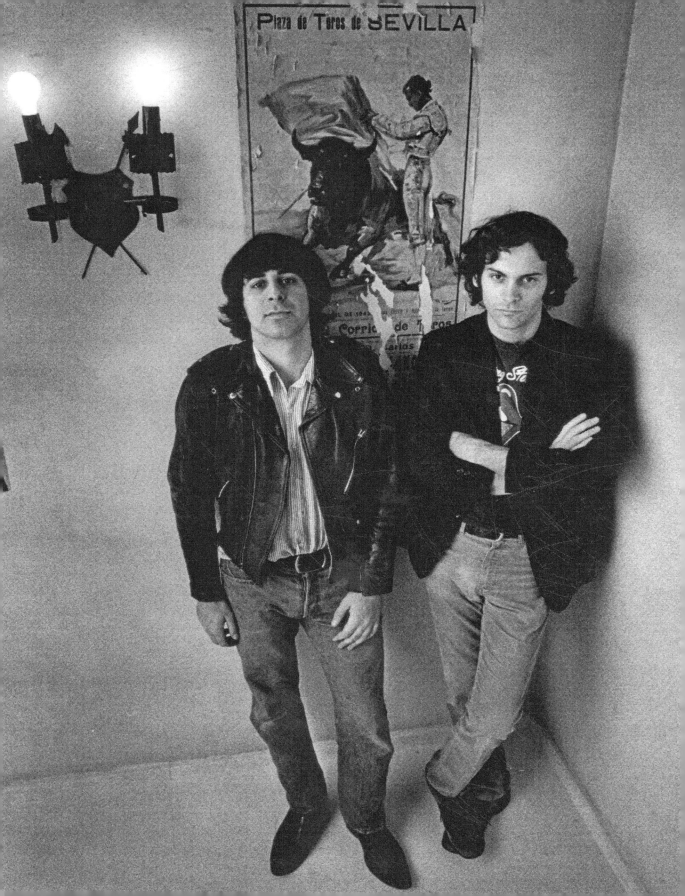

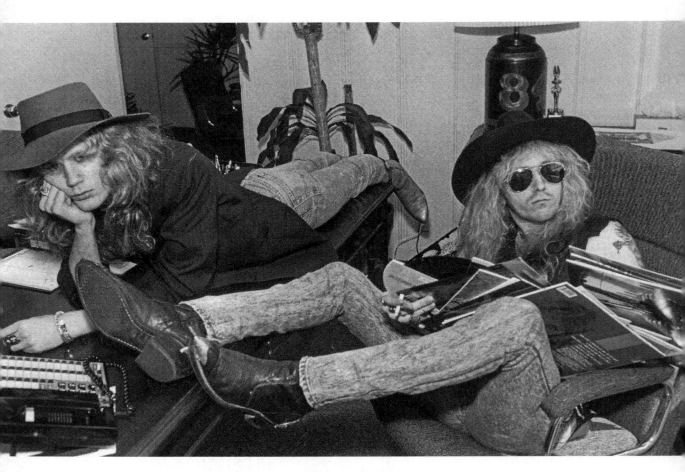

Rock City Angeles. Andy Panick and the late Bobby Durango, A.K.A. Bobby Bondage, A.K.A. Bobby St. Valentine. The Rock City Angels started out as the punk band the Abusers.
1988, Steve Grayson (Order #124260)

Opposite: **Kill For Thrills.** Gilby Clarke, guitarist later joined Guns N' Roses, replacing Izzy Stradlin.
1989, Lucy Snowe (Order #54876)

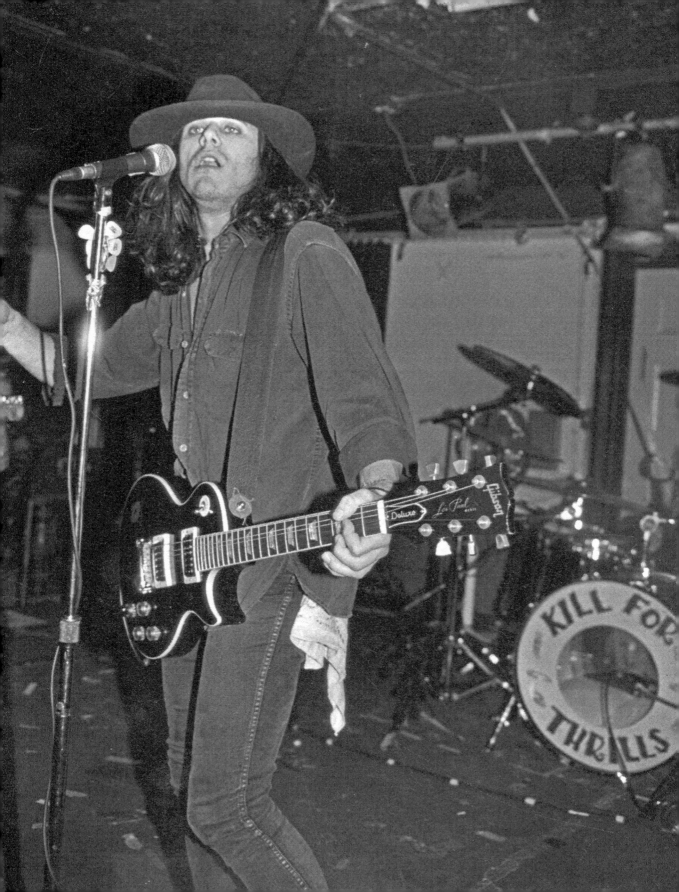

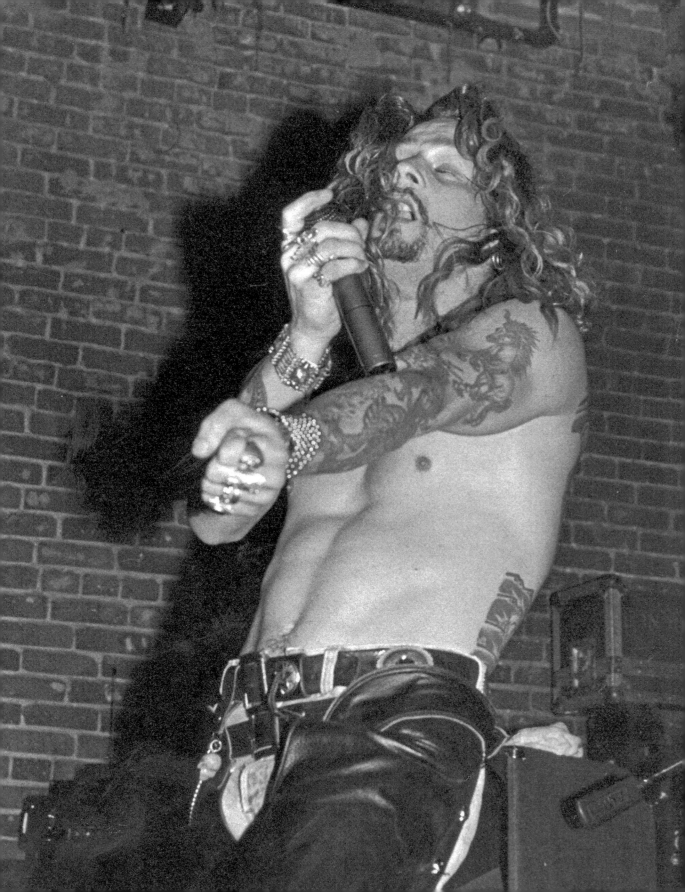

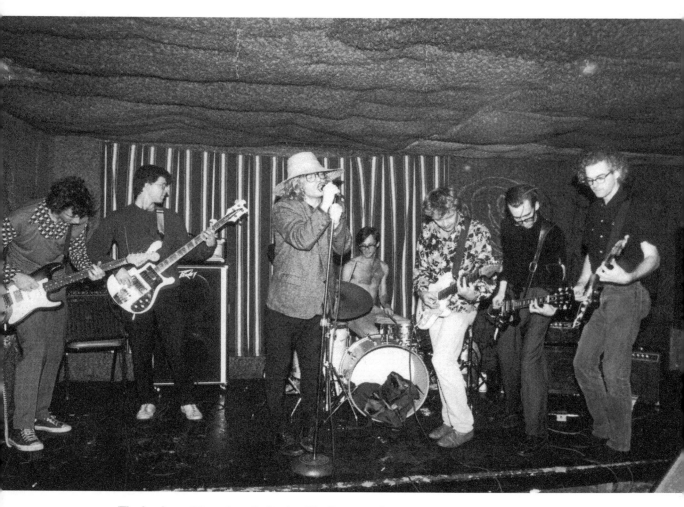

Thelonious Monster. Guitarist Dix Denney, formerly of The Weirdos, and K.K. Barrett, formerly of The Screamers, join lead singer Bob Forrest, bassist John Huck, drummer Pete Weiss and guitarists Chris handsome and Bill Stobaugh to form the alternative rock band Thelonius Monster. While they didn't achieve major commercial success, the band was a fixture on the L.A. club scene and had a dedicated following.
1986, unknown. (Order #124265)

Opposite: **Little Caeser.** Ron Young, A.K.A. Little Caeser fronted the hard rock band that Geffen Records hoped would succeed Guns N' Roses as a top selling rock band.
1989, Lucy Snowe (Order #54897)

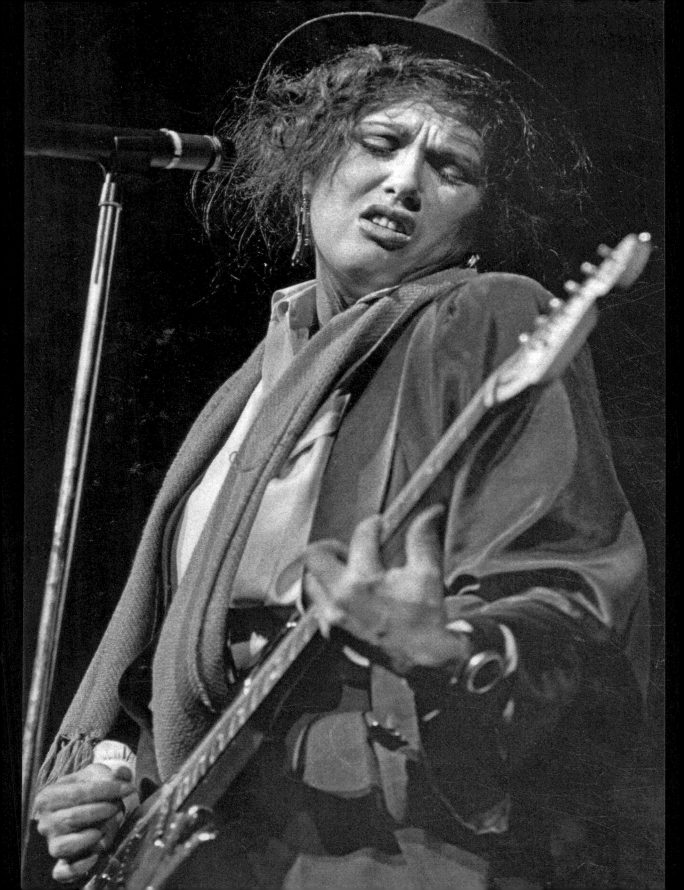

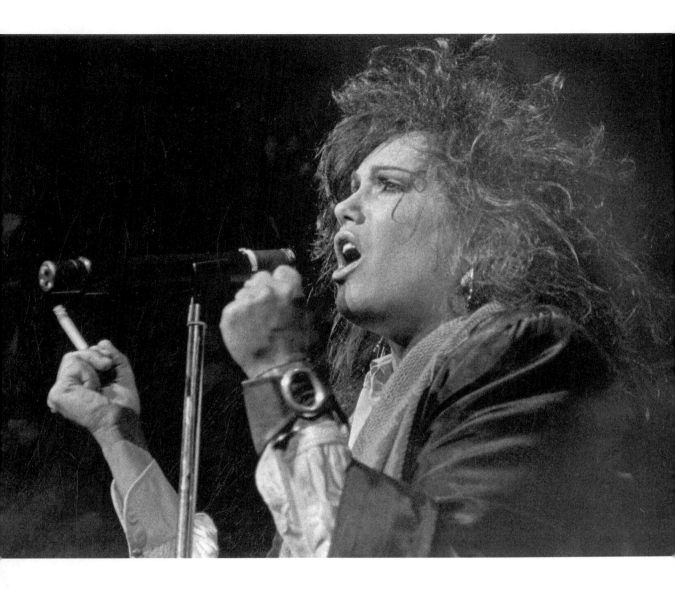

The Motels. The Motels, featuring Martha Davis, performing at the Universal Amphitheater. Originally from Berkeley, they played the Los Angeles clubs in the late 1970s before hitting big in 1982 with "Only the Lonely."
1983, Paul Chinn (Order #124294, #124293 opposite)

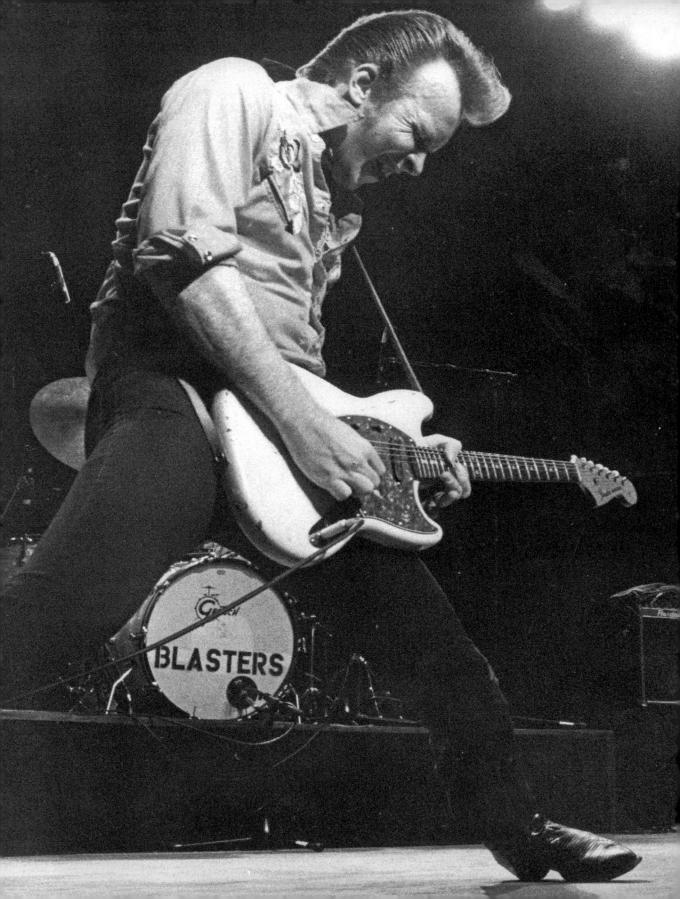

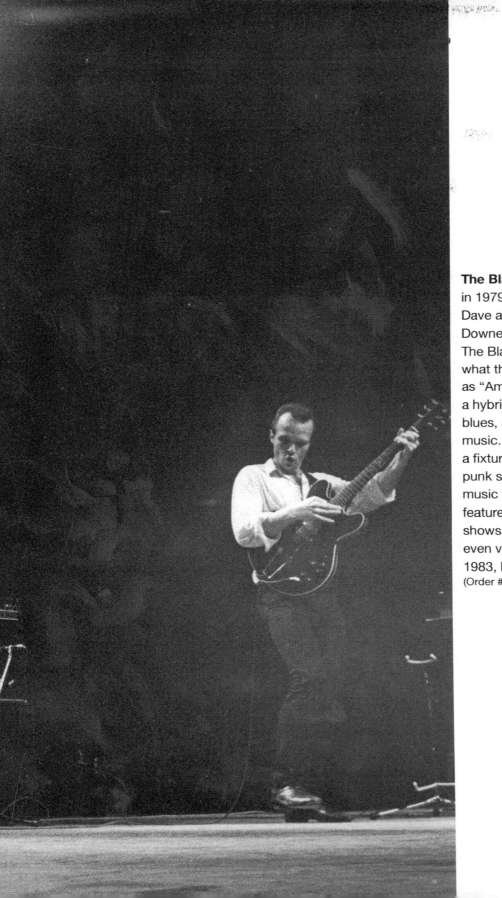

The Blasters. Formed in 1979 by brothers Dave and Phil Alvin of Downey, California, The Blasters played what they referred to as "American Music": a hybrid of rockabilly, blues, and mountain music. The band was a fixture in the L.A. punk scene and their music was prominently featured in television shows, movies and even video games. 1983, Michael Edwards (Order #121777)

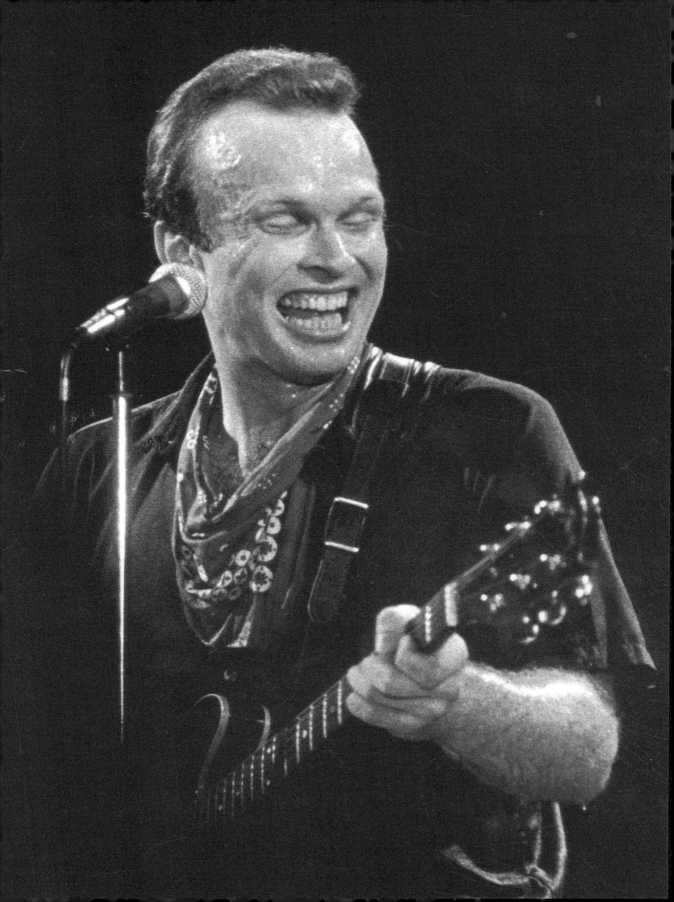

The Blasters. Live at the Hollywood Palladium.
1983, Michael Edwards (Order #124292, #124291 opposite)

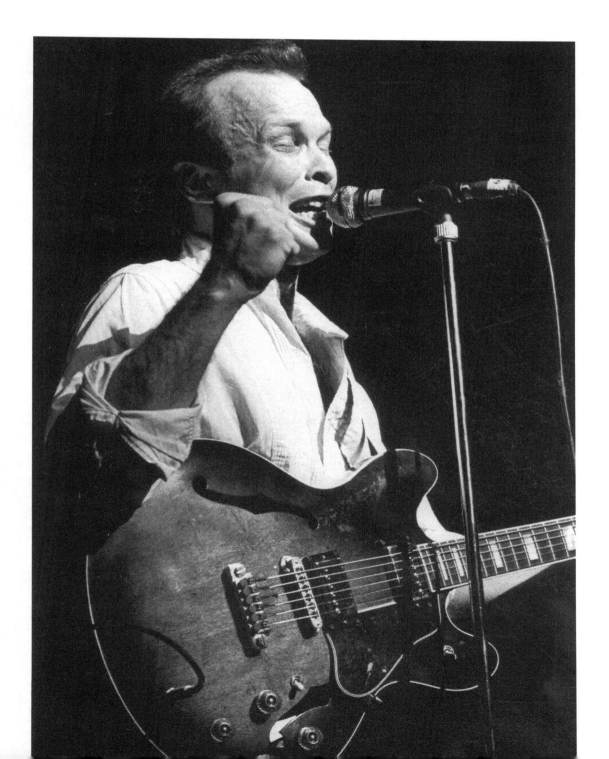

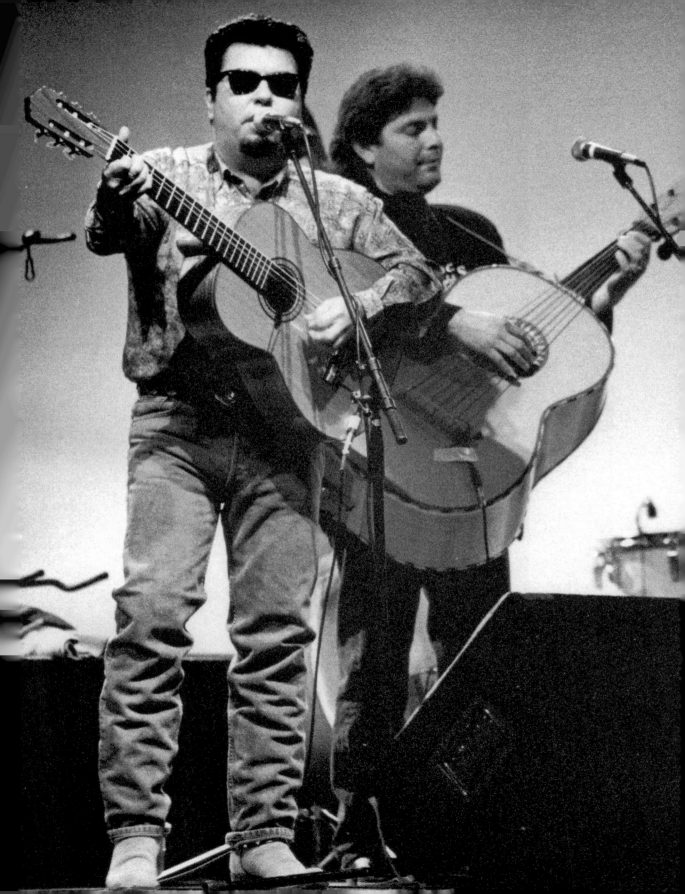

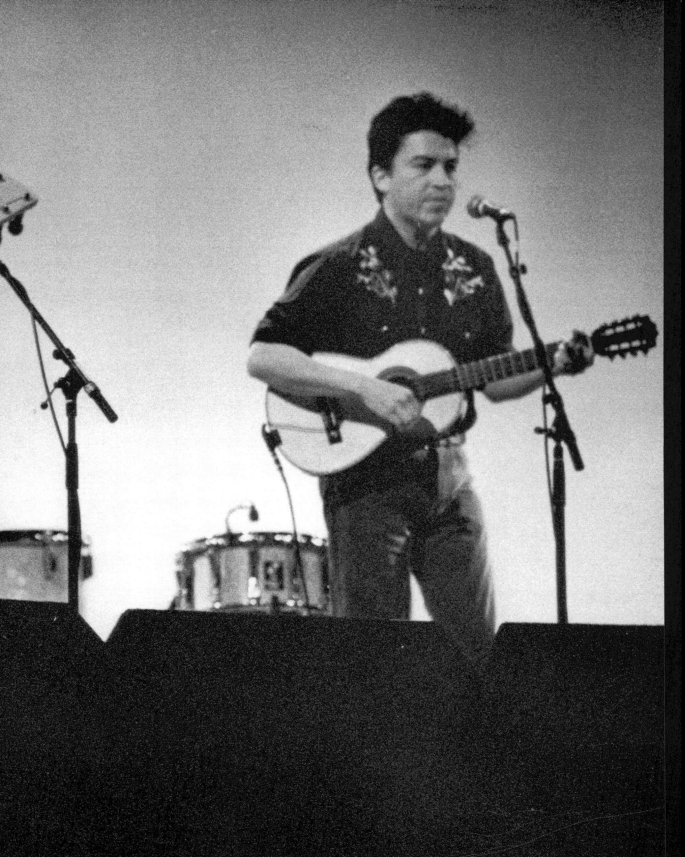

Los Lobos. Louie Perez, David Hidalgo, Conrad Lozano, Cesar Rosas.
ca 1987, Rob Brown (Order #76725)

Overleaf: **Los Lobos.** Founded by Garfield High School classmates David
Hidalgo and Louis Perez in the mid 1970s, their early sets of Top 40 covers
gradually gave way to more traditional Mexican rhythms and melodies
combining rock, folk, Tex-Mex, and rhythm and blues, and garnered them
multiple Grammy awards and critical acclaim.
1988, Leo Jarzomb (Order #74261)

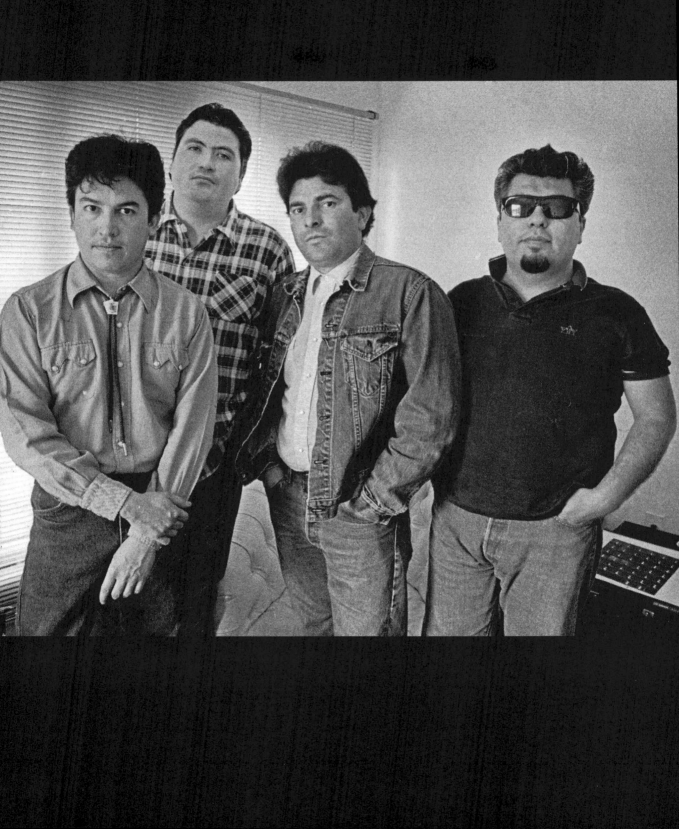

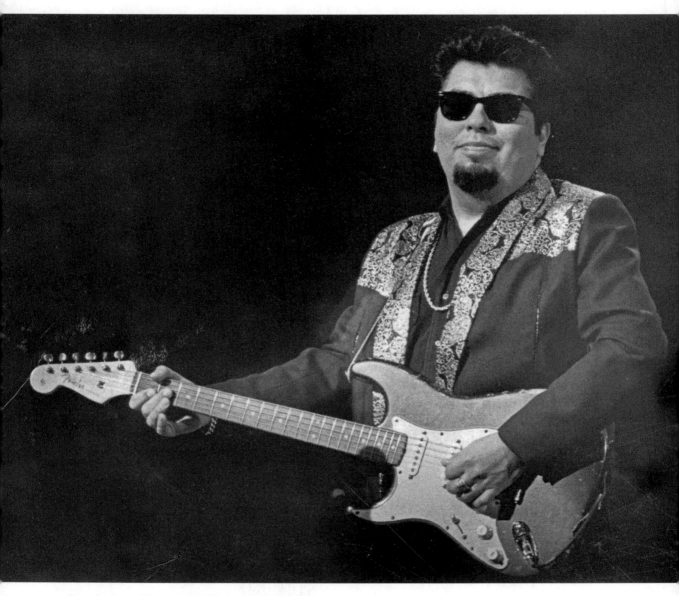

Los Lobos. Live at the Universal Amphitheater.
1987, Javier Mendoza (Order #76682)

Opposite: **The Germs.** Lead singer Darby Crash and his skateboard. Considered to be one of the most influential of the L.A. punk bands, The Germs' wildly chaotic live shows were featured in the movie *The Decline of Western Civilization*.
1980, Gary Leonard (Order #29659)

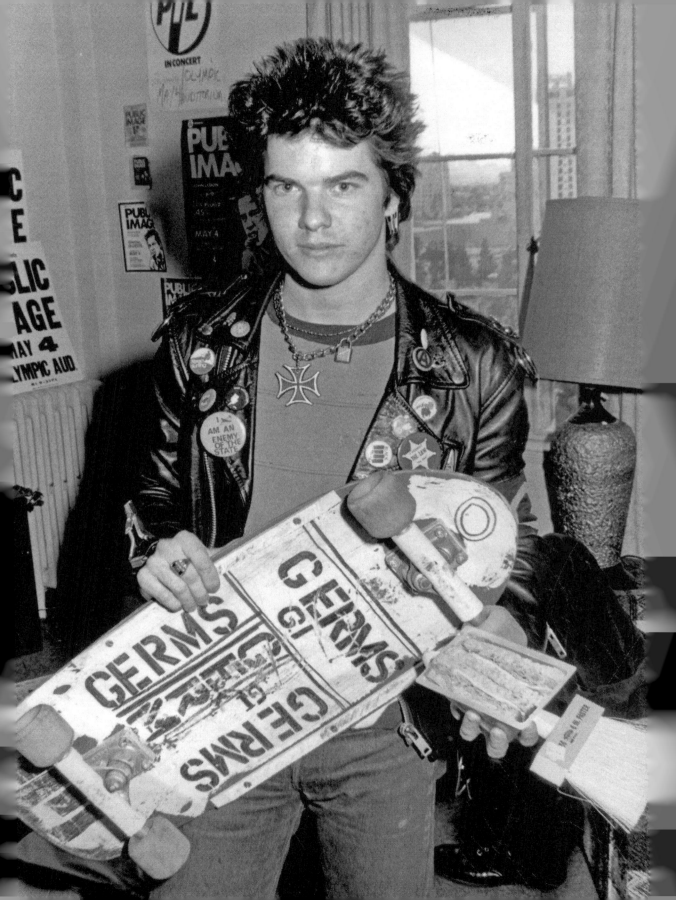

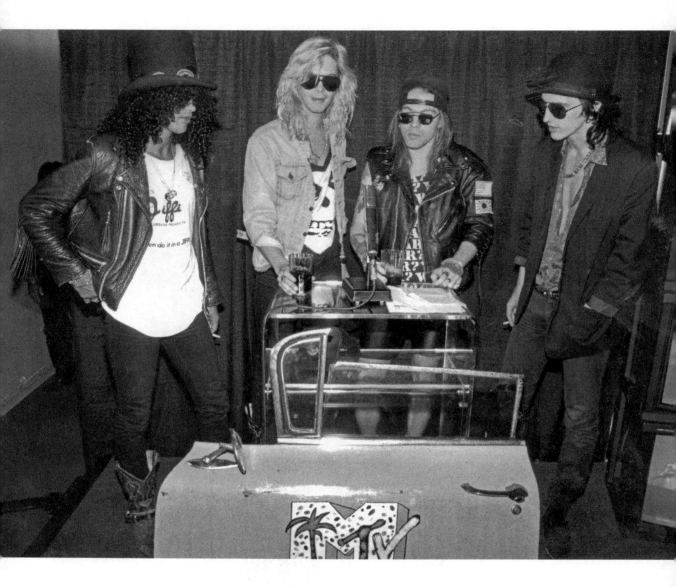

Guns N' Roses. Slash, Duff McKagan, Axl Rose and Izzy Stradlin present the nominees at the MTV Music Video Awards. Their constant presence on the Hollywood club scene led to a contract with Geffen Records, and their album *Appetite For Destruction* topped the Billboard charts and became the best selling record in Geffen's history.
1988, Akili-Casundria Ramsess (Order #121771, #124273 opposite)

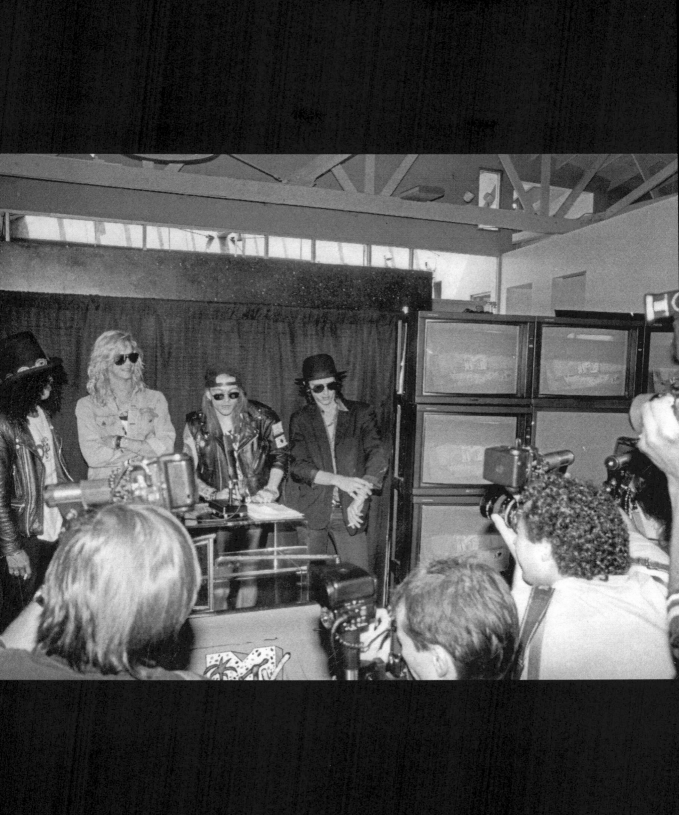

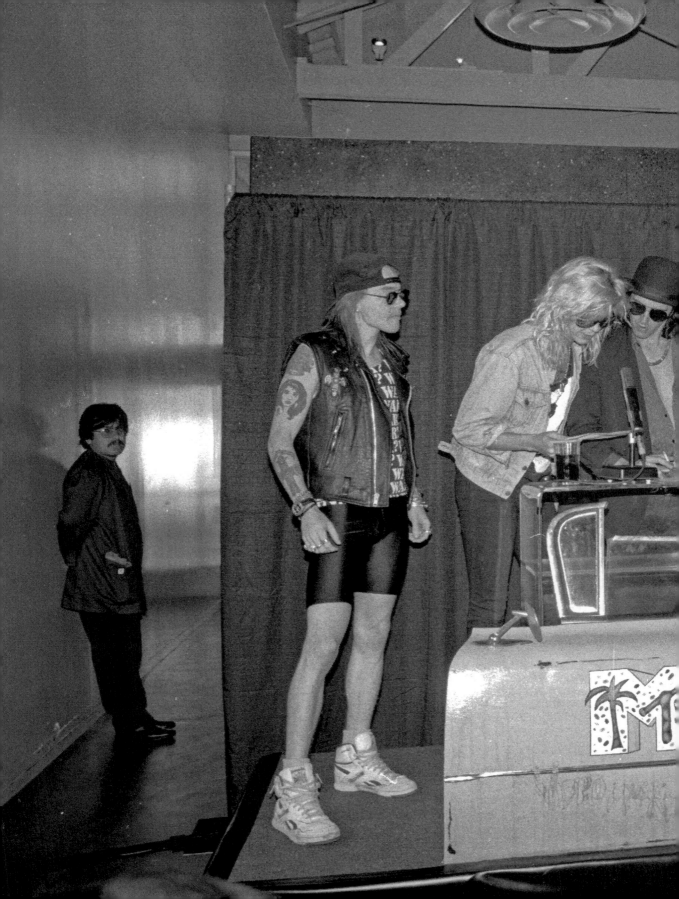

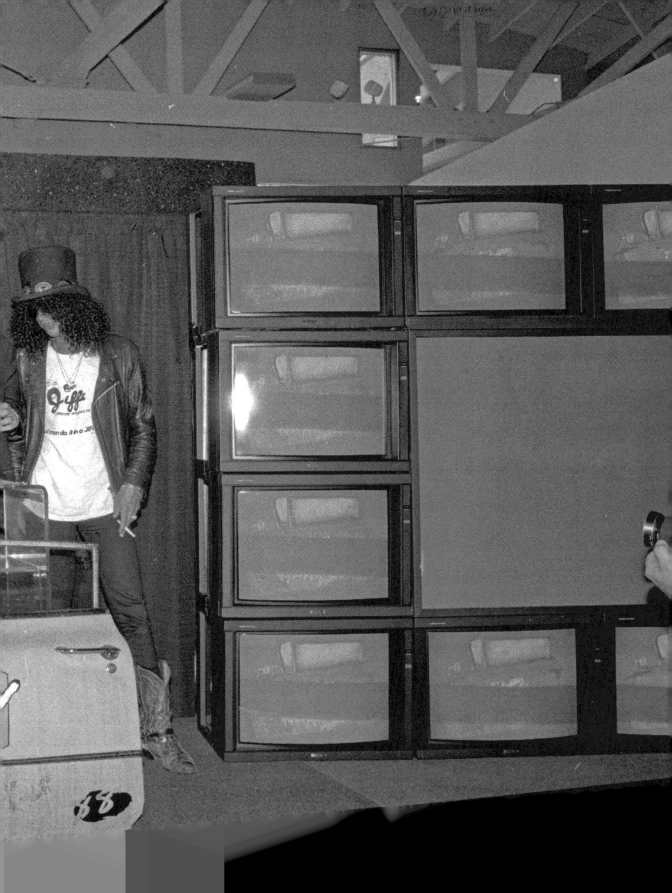

Opposite and Overleaf: **Guns N' Roses.**
1988, Akili-Casundria Ramsess

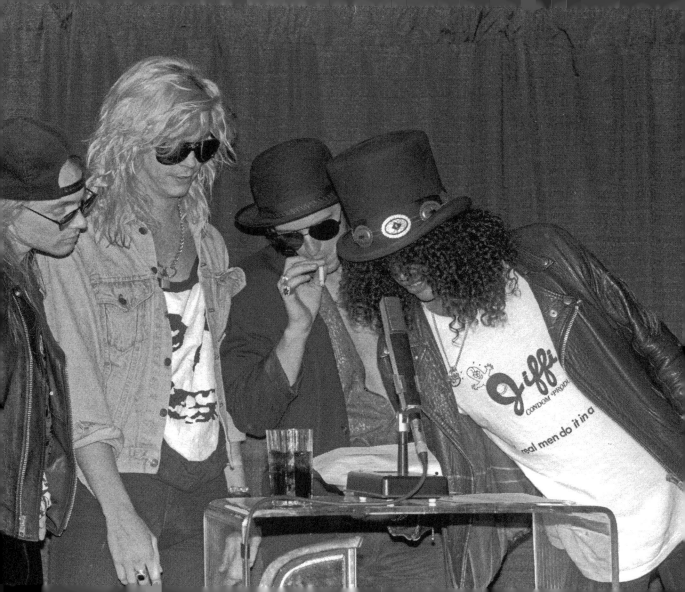

Opposite and pages 138-139: **Monsters of Rock.** The Monsters of Rock show at the L.A. Coliseum featured headliners Van Halen, Metallica, The Scorpions and Dokken.
1988, Steve Grayson (Order #59448)

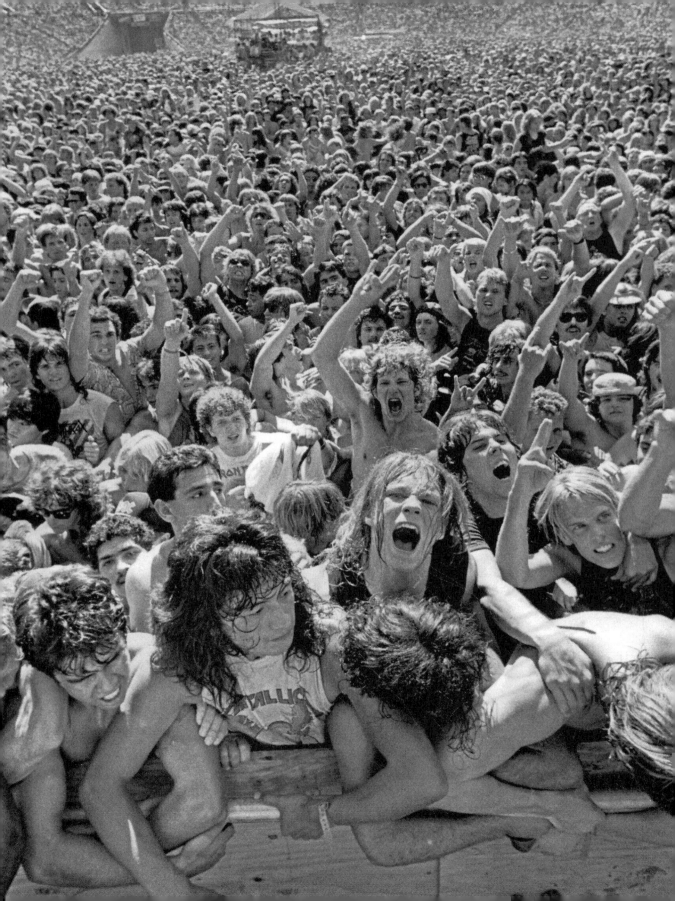

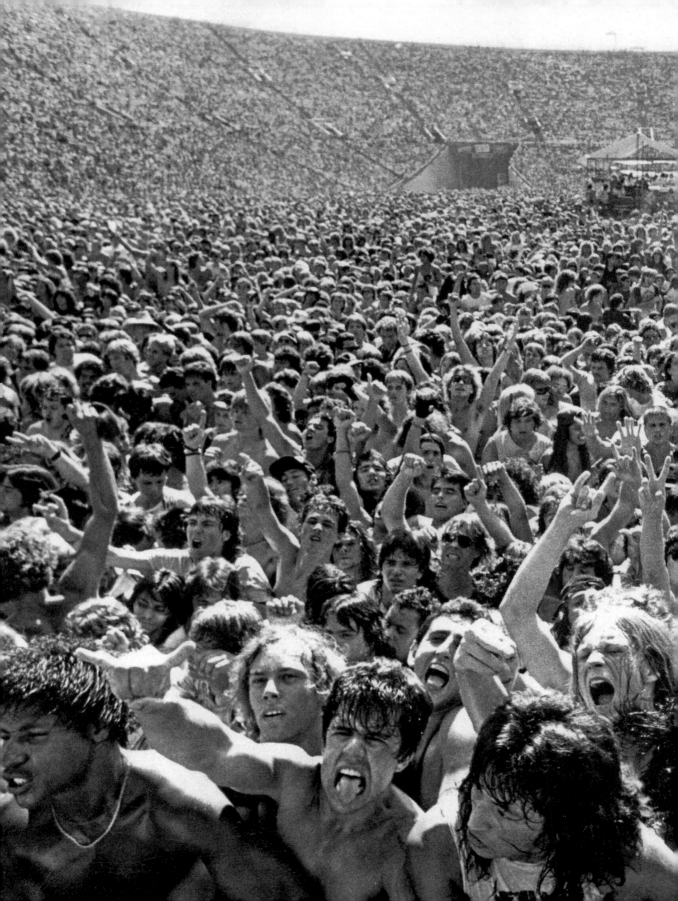

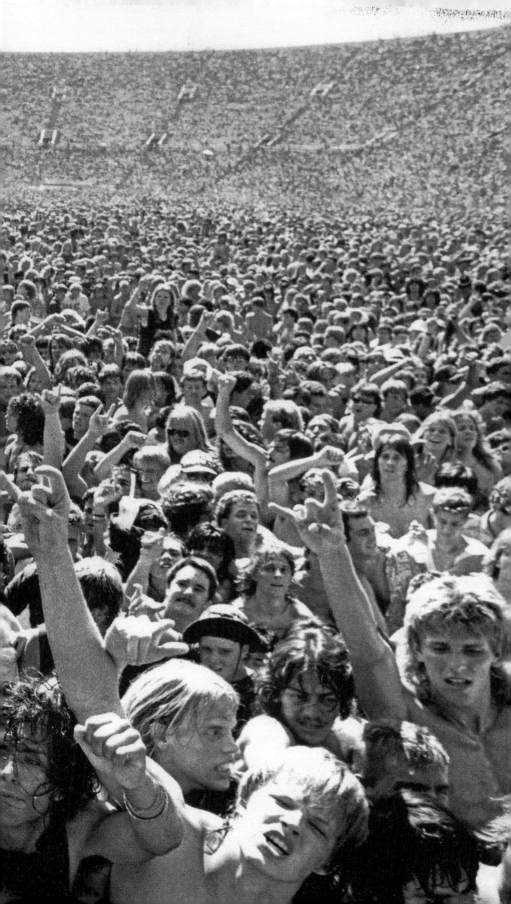

BANK OF AMERICA

RAINBOW

BILL GAZZARRI PRESENTS
TUES. COUNT AREU COMEDY SHOW
WED. AUDITIONS & REHERSALS FOR
JIM MORRISON ROCK OPER
THURS. SHIRE BAD BUPY ORPHA
STRAIT LACE PALISADES

Gazzarri's
GROUP AUDITIONS
CALL ... 38406

BEVERY SL
BATTARI
THE

bar
gril

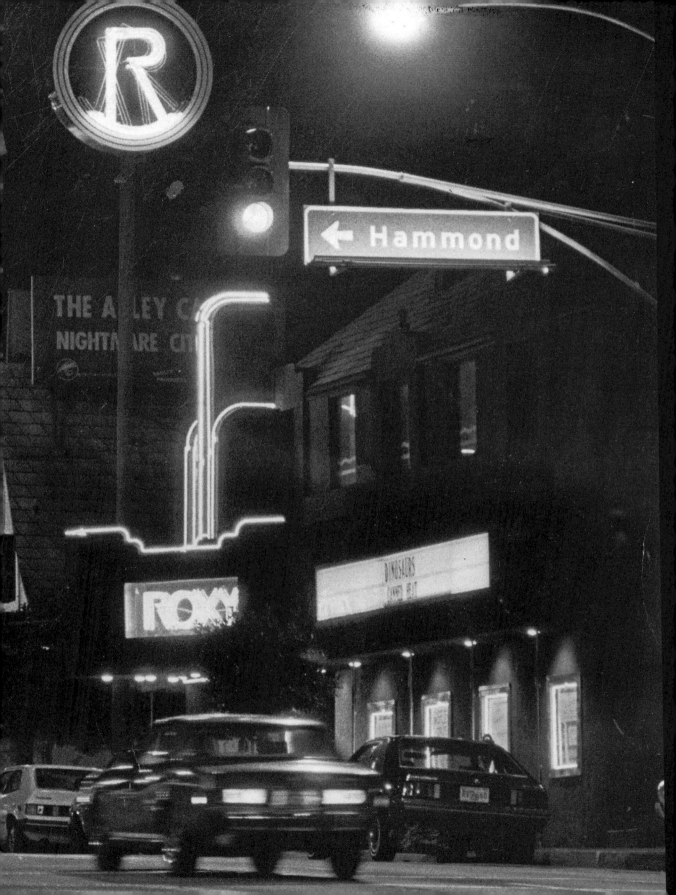

Opposite: **The Roxy Theater.** 1980, Dean Musgrove (Order #45023)

Overleaf: **The Sunset Strip.** ca 1984, Paul Chinn (Order #45071)

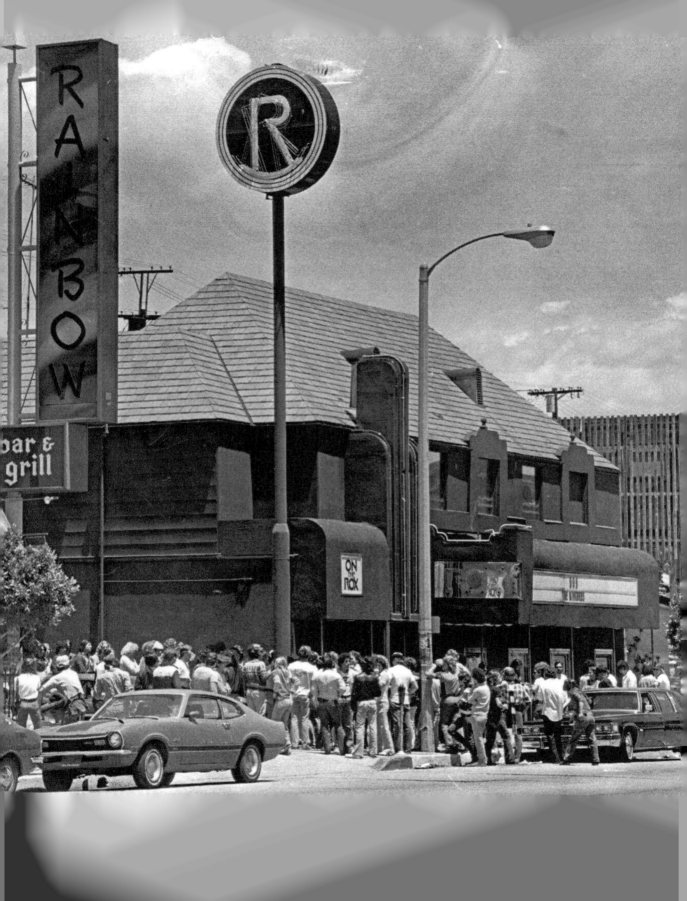

The Starwood. ca 1981, Gary Leonard (Order #29435)

Opposite: **The Starwood.** 1981, Gary Leonard (Order #58815)

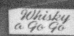

Whisky
a Go Go

FINAL WEEK
SEP 15 20-20
THE BEAT
16 SURF
PUNKS
TOP JIMMY

← San Vicente
Clark St →

THE LAST
NIGHT THE
PLIMSOULS
AND GUESTS

INSTANT PRINTING
COMMERCIAL
1 & BILLING
PRICE LISTS

Scott

AT THE WHISKY

FRIDAY NIGHT:1

Whisky a Go Go

20/20
THE BEAT
CYLINDER

Overleaf: **The Whisky a Go-Go.** 1982, Paul Chinn (Order #45079)

Opposite: **Al's Bar.** 1981, Anne Knudsen (Order #83362)

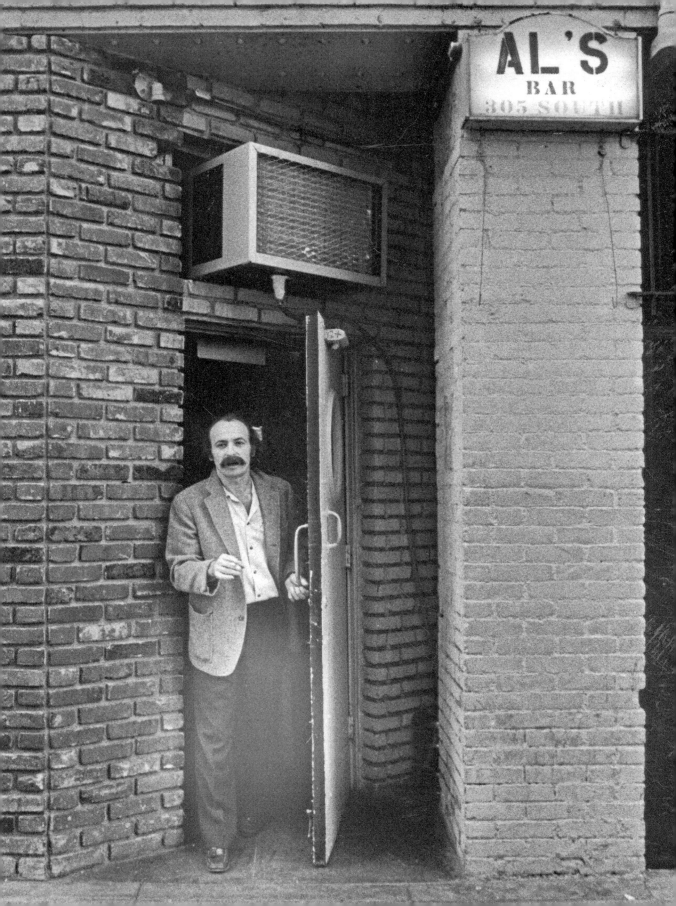

Roxy Theater. ca 1985, Paul Chinn (Order #45073)

Pages 154-155: **Tower Records on Sunset Blvd.**
ca 1980, Roy Hankey (Order #59924)

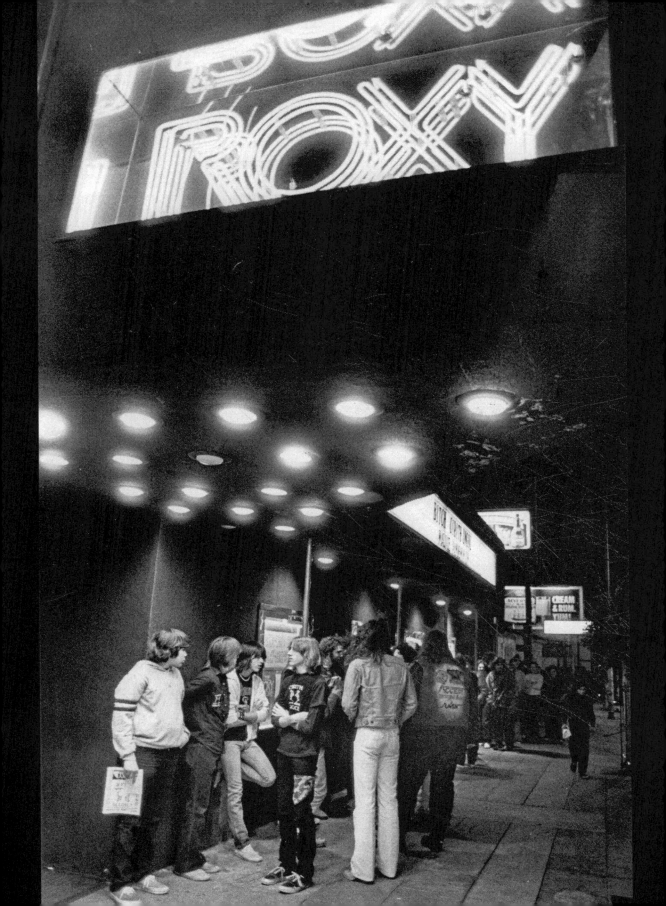

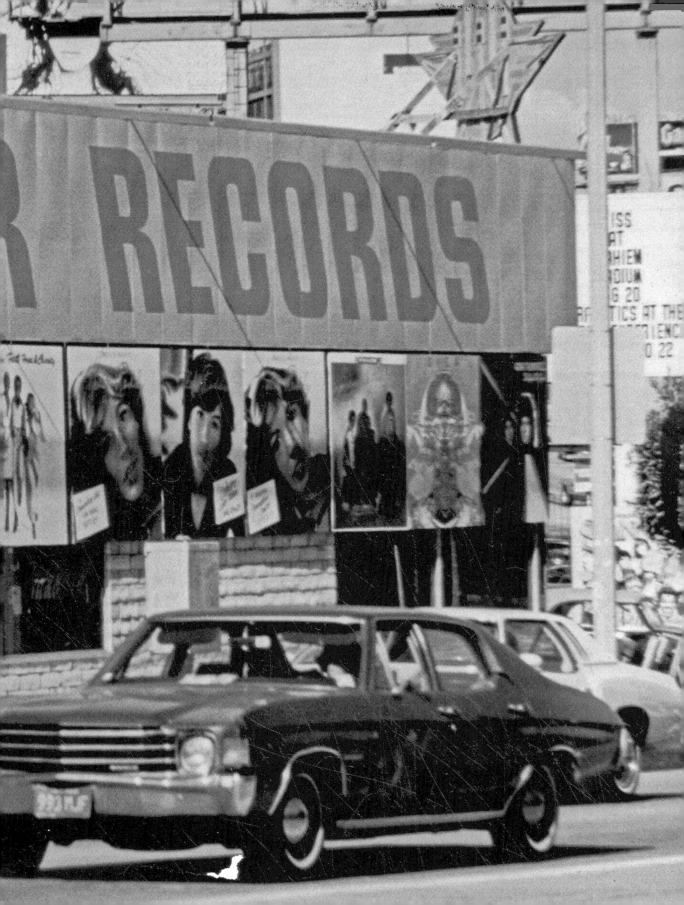

About the Authors

Wendy Horowitz left New Haven, Connecticut in 1988 for greener pastures in L.A. after meeting Redd Kross on tour, and frequented Raji's, The Gaslight, The Lingerie, The Coconut Teaszer and ate three meals a day at Ben Franks. Before joining the Photo Collection of Los Angeles Public Library, she was an LAPL children's librarian, a Warner Bros. associate archivist, a researcher for Rhino Entertainment Home Video and F.I.L.M. Archives, a film booker for Streamline Pictures, a projectionist, a receptionist, an artist's model, and a switchboard operator. Besides photography, Wendy also collects 16mm films, particularly of people in their time, and comic books from the 1950s.

Christina Rice is a librarian, archivist, author, wife, and mother. She obtained an MLIS from San Jose State University and now oversees the Photo Collection at the Los Angeles Public Library. She is the author of *Ann Dvorak: Hollywood's Forgotten Rebel* (University Press of Kentucky) and multiple issues of the *My Little Pony* comic book series (IDW Publishing). She lives in Los Angeles with her husband, writer Joshua Hale Fialkov, their daughter, two dogs, and a disgruntled cat. One day, she hopes to live in a house big enough to fit her Guns N' Roses pinball machine which has been in her mom's garage for way too long.

About the Photo Collection

The Los Angeles Public Library (LAPL) began collecting photographs sometime before World War II and had a collection of about 13,000 images by the late 1950s. In 1981, when Los Angeles celebrated its 200th birthday, Security Pacific National Bank gave its noted collection of historical photographs to the people of Los Angeles to be archived at the Central Library. Since then, LAPL has been fortunate to receive other major collections, making the library a resource worldwide for visual images.

Notable collections include the "photo morgues" of the *Los Angeles Herald Examiner* and *Valley Times* newspapers, the Kelly-Holiday mid-century collection of aerial photographs, the Works Progress Administration/Federal Writers Project collection, the Luther Ingersoll Portrait Collection, along with the landmark *Shades of L.A.*, an archive of images representing the contemporary and historic diversity of families in Los Angeles. Images were chosen from family albums and copied in a project sponsored by Photo Friends.

The Los Angeles Public Library Photo Collection also includes the works of individual photographers, including Ansel Adams, Herman Schultheis, William Reagh, Ralph Morris, Lucille Stewart, Gary Leonard, Stone Ishimaru, Carol Westwood, and Rolland Curtis.

Over 100,000 images from these collections have been digitized and are available to view through the LAPL website at **http://photos.lapl.org.**

About Photo Friends

Formed in 1990, Photo Friends is a nonprofit organization that supports the Los Angeles Public Library's Photograph Collection and History & Genealogy Department. Our goal is to improve access to the collections and promote them through programs, projects, exhibits, and books such as this one.

We are an enthusiastic group of photographers, writers, historians, businesspeople, politicians, academics, and many others, all bonded by our passion for photography, history, and Los Angeles.

Since 1994, Photo Friends has presented a series called *The Photographer's Eye*, which spotlights local photographers and their work. These talks are presented bi-monthly. In 2011, Photo Friends inaugurated *L.A. in Focus*, a lecture series that features images drawn primarily from the Photo Collection, and other topics on Los Angeles themes. We have presented programs on L.A. crime, the San Fernando Valley, Kelly-Holiday aerial photographs, and L.A.'s themed environments, among others.

With initial funding from the Ralph M. Parsons Foundation, Photo Friends sponsored *L.A. Neighborhoods Project* by commissioning photographers to create a visual record of the neighborhoods of Los Angeles during the early part of the 21st century (all now part of the collection). To ensure the Library's Collection will continue to reflect such an important part of Los Angeles's history, a generous grant enabled Photo Friends to hire five contemporary photographers to document present-day industrial L.A. These images have become part of LAPL's permanent collection and are available through the library's photo database. Photo Friends also curates photography exhibits on display in the History Department and locations around the city.

Photo Friends is a membership organization. Please consider becoming a member and helping us in our work to preserve and promote L.A.'s rich photographic resource. All proceeds from the sale of this book go to support Photo Friends's programs.

photofriends.org

This catalog was published in conjunction with
*From Pop to the Pit: The LAPL Photo Collection celebrates
the Los Angeles Music Scene 1978-1989,* a photo exhibit on display in the
Central Library History & Genealogy Department Jan. 8–June 28, 2015.

Thank You!

Kim Creighton, Brian Kehew, Lisa Sutton, Jeff McDonald, Steven McDonald,
Leonard Phillips, Jason Shapiro, Charlotte Elberfeld, Andrew Sandoval,
Henry Rollins, Lucy Snowe. Extra special thanks to Gary Leonard.

From Pop to the Pit:
The LAPL Photo Collection Celebrates the Los Angeles Music Scene 1978-1989
Edited by Christina Rice
Copyright © 2014 Photo Friends of the Los Angeles Public Library
Images © Los Angeles Public Library Photo Collection

PHOTO FRIENDS
of the LOS ANGELES PUBLIC LIBRARY
PUBLICATIONS

Published by:
Photo Friends of the Los Angeles Public Library
c/o Future Studio
P.O. Box 292000
Los Angeles, CA 90029

www.photofriends.org

Designed by Amy Inouye, Future Studio Los Angeles

Special quantity discounts available when purchased in bulk by corporations,
organizations, or groups.
Please contact Photo Friends at: **photofriendsla@gmail.com**

ISBN-13: 978-0692703298

Printed in the United States

photo
friends
LOS ANGELES PUBLIC LIBRARY

Made in the USA
San Bernardino, CA
28 February 2017